"Indispensable for all who have to keep in touch with the manifold activities of women in public and social life."—*Standard.*

The
Englishwoman's Year Book
and Directory
1906

EDITED BY

EMILY JANES

ORGANISING SECRETARY TO THE NATIONAL UNION OF WOMEN WORKERS OF GREAT BRITAIN AND IRELAND

TWENTY-SIXTH YEAR OF ISSUE

Crown 8vo Cloth

2/6 net

"IT IS A CURIOUS FACT THAT MANY GIRLS WHO ARE LOOKING ABOUT FOR EMPLOYMENT WHICH WILL BRING IN AN INCOME, NEGLECT TO PURCHASE A USEFUL MANUAL LIKE THE 'ENGLISHWOMAN'S YEAR BOOK.' BY STUDYING IT THEY WOULD AT LEAST BE WARNED AWAY FROM OCCUPATIONS THAT HAVE NOTHING TO OFFER. I HEARD LATELY OF A YOUNG LADY IN THE COUNTRY WHO HAD SET HER HEART ON BECOMING A FACTORY INSPECTOR. SHE HAD NO SPECIAL EXPERIENCE AND NO QUALIFICATIONS FOR THE POST, AND A GLANCE AT THE 'YEAR BOOK' WOULD HAVE SHOWN HER THAT SUCH APPOINTMENTS ARE VERY FEW AND VERY DIFFICULT TO OBTAIN."—"*LORNA*" in the *BRITISH WEEKLY.*

PUBLISHED BY

ADAM & CHARLES BLACK, Soho Square, London

THE WRITERS' AND ARTISTS'

YEAR-BOOK

THE
WRITERS' AND ARTISTS'
YEAR-BOOK
1906

A DIRECTORY FOR

WRITERS, ARTISTS AND PHOTOGRAPHERS

PUBLISHED BY

ADAM AND CHARLES BLACK

Soho Square, London, W.

PREFACE

THE difficulty of knowing where to place stories and articles is one that confronts not only the tyro but the man with considerable experience. It is impossible to buy up a whole bookstall in order to search out a likely paper, equally impossible to carry in one's head the innumerable products of the daily, weekly, and monthly press. Even though, unlike some other publications of the kind, we will assume that he who has the sense to write an article has also the sense not to send theology to a comic paper, and *vice-versâ*, we are aware that there are still infinite shades and gradations among the contents of papers, and that great discrimination is required for the correct placing of a MS. The present annual is an attempt to indicate the requirements of editors so as to meet that want.

In the list of journals here given very special attention has been paid to all details of importance, such as the length of a MS. likely to be accepted, the kind and quality of matter suitable, and the style of illustration generally employed. It is true that several papers appear with only an address, but it may be noted that in most cases these are only technical organs, and carry their requirements in their titles.

The Writers' Year-Book in its old form has already attained a measure of popularity; it has now been completely re-written, and as the *Writers' and Artists' Year-Book* will prove serviceable also to the ever increasing host of illustrators, which bids fair to rival in numbers even the mighty army of contributors. In

addition to the list of book publishers will be found a list of those art publishers who are willing to take designs, posters, and cards of various sorts. The names of literary agents are given also, and at the end of the book there is a classified list of papers indicating those that accept short stories, general articles, serials, and other kinds of matter. With the enormous number of openings now available for the short story and article writer, anyone with the necessary style, knowledge, and the faculty of selection cannot fail to place his MSS., and of all pleasant forms of work few are more delightful than that which falls to the lot of the free lance, who is fairly confident of finding a market for his work.

ESSENTIAL DETAILS.

Whenever it is possible have MSS. type-written; if not, very clearly written with plenty of space.

Write your name and address on every MS.

Pack your MSS. flat, not rolled or folded.

If you want to see them back again in case of unsuitability enclose a large envelope that will take them flat, and send it ready stamped and addressed for return.

A short note pointing out a special feature or noting previous work is not unacceptable, but it should be concise, and enclosed with the MSS.

<div align="right">THE EDITOR.</div>

CONTENTS

THE
WRITERS' AND ARTISTS'
YEAR BOOK, 1906

ACADEMY, P. Anderson Graham; Harold Child *(Assist.)*, *20, Tavistock Street, Covent Garden, W.C.*
 3d. W.—Short articles on literary subjects, about 1,500-2,000 words, the subject of which must have been previously submitted in a letter to the editor. *Payment:* By arrangement with the editor.

ACCOUNTANT, Robert Gee, *34, Moorgate Street, E.C.*
 6d. W.—

ACCOUNTANT'S JOURNAL, Robert Gee, *34 Moorgate Street, E.C.*
 9d. M.—

AERONAUTICAL JOURNAL (illustrated), Eric Stuart Bruce, *29, Chancery Lane, E.C.*
 1s. Q.—Contains the latest information on balloons, flying machines, airships, kites, and all aerial matters; also, the transactions of the Aeronautical Society of Great Britain. Is illustrated.

AFRICAN WORLD, *34, Copthall Avenue, E.C.*
 6d. W.—News and notes relating to Colonial Africa.

AGRICULTURAL GAZETTE, *9, New Bridge Street, E.C.*
 1d. W. (Monday).—A paper for practical farmers, containing articles on agriculture, markets, etc.
Illustrations: Photos.

ALL STORY MAGAZINE, *Flat Iron Building, New York.*
 6d. M.—Contains short stories of varying lengths. Contributors are requested to transmit return postage. No illustrations.

ALLY SLOPER'S HALF HOLIDAY, *99, Shoe Lane, E.C.*
 1d. W. (Saturday).—An illustrated comic paper containing humorous sketches, jokes, etc. Short stories, comic articles, and jokes, may be submitted. *Payment* by arrangement.

ALPINE JOURNAL, George Yeld, *39, Paternoster Row, E.C.*
 2s. Q.—A record of mountain adventure and scientific observation, by members of the Alpine Club. Articles by non-members of the Club are occasionally admitted, but not often. *No payment* is made. Most of the illustrations are from photographs taken by members.

AMATEUR GARDENING, T. W. Sanders, *149, Aldersgate Street, E.C.*
 1d. W. (Saturday).—A paper devoted to the interest of amateur gardeners, brightly written, practical articles on all phases of popular gardening are required. Articles on natural history and special gardening subjects are also considered for the Christmas number. A *preliminary*

letter is desirable. Stamped addressed envelope to be enclosed with manuscript for return of latter in case of rejection.

Illustrations: Wash drawings of flowers or garden subjects; also photographs.

AMATEUR PHOTOGRAPHER, A. Horsley Hinton, *52, Long Acre, W.C.*
2d. W. (Tuesday).—A journal devoted to photography and the kindred arts. The results of investigations of processes and methods of photography are acceptable. Descriptive articles of subjects worth photographing, and articles dealing especially with the artistic side or artistic possibilities of photography may be sent. Photographs possessing exceptional pictorial merit accepted for illustrations and paid for at usual rates. A *preliminary letter* is not required. *Payment* made shortly after the last day of each month.
Illustrations: Photographs.

AMERICAN HISTORICAL REVIEW, *St. Martin's Street, W.C.*
3s. 6d. net.—

AMERICAN JOURNAL OF ARCHAEOLOGY, *St. Martin's Street, W.C.*
4s. 6d. net.—

ANGLER'S NEWS, A. R. Mathews; A. E. Jackson, *4 and 5, Gough Square, Fleet Street, E.C.*
1d. W.—

ANGLO-JAPANESE GAZETTE AND ANGLO-JAPANESE TRADE REVIEW, Leslie Elpinstone, *39, Seething Lane, E.C.*
6d. M. (20th).—Articles should not exceed 1,500 words, and should deal with Far Eastern topics.

ANGLO-RUSSIAN, Iaakoff Prelooker, *21, Paternoster Square, E.C.*
M. 1s. 6d. per annum.—Articles, political, religious, commercial and literary, dealing with Russia, not exceeding 5,000 words. *Payment* by arrangement.
Illustrations: Bearing on the same subject.

ANIMALS' FRIEND, *York House, Portugal Street.*
2d. M. (26th).—An illustrated journal devoted to animals and their humane treatment. Articles, stories, notes, etc., on this subject are accepted. *No payment* is made.

ANNALS AND MAGAZINE OF NATURAL HISTORY, Albert C. L. G. Günther, F.R.S., and others, *Red Lion Court, Fleet Street, E.C.*
Technical articles, embodying the results of original research.

ANNALS OF SCOTTISH NATURAL HISTORY, *10, Castle Street, Edinburgh.*
2s. 6d. Q.

ANSWERS, *Carmelite Street, E.C.*
1d. W. (Thursday).—Articles short and original, from 700 to 1,400, are considered. Also short stories from 2,000 to 3,000 words. Jokes, paragraphs, etc., also acceptable. No *preliminary letter* required. *Payment:* One guinea per column. No MSS. considered unless accompanied by a fully stamped and addressed envelope.

ANTIQUARY, G. L. Apperson, *62, Paternoster Row, E.C.*
6d. M. (28th).—Articles on matters of bibliographical or antiquarian interest may be sent for consideration.
Illustrations: Line or photographs.

ARCHITECT, *Imperial Buildings, Ludgate Circus, E.C.*
4d. W. (Friday).—

ARCHITECTURAL REVIEW, Mervyn Macartney, *6, Great New Street, E.C.*
 1s. M.—Contains articles dealing with design, archæology, or construction.
 Illustrations: Photographs or drawings.

ARMY AND NAVY GAZETTE, *22, Essex Street, Strand, W.C.*
 6d. W. (Saturday).—The Gazette contains articles on subjects of interest connected with both Services. Short contributions, articles or paragraphs brightly written, concerning military and naval matters, reports of naval or military proceedings, are acceptable. A *preliminary letter* is imperative. *Payment:* 10s. per column.

ART JOURNAL, A. Yockney, *7, City Garden Row, City Road.*
 1s. 6d. M. (25th).—Contributions on artistic subjects are generally acceptable. News connected with artists is also inserted. *Preliminary letter* desirable. *Payment* on publication.
 Illustrations: Line, wash, or photographs.

ARTS AND CRAFTS, Montague Marks, *137, Strand, W.C.*
 1s. net, M.—

ATHENAEUM, *Bream's Buildings, Chancery Lane, W.C.*
 3d. W. (Friday)—Articles on literary matters, but only such as are of special interest or importance and exhibit research, are considered. No translations. *Preliminary letter* is advisable. *Payment* varies according to matter. *Remarks:* No reviews of books required, descriptive articles or essays are chiefly desired.

AUTHOR, *39, Old Queen Street, Storey's Gate, S.W.*
 M. (for 10 months, annual subscription, 5s. 6d.).—Primarily the organ of the Authors' Society. Articles from 1,500 to 2,000 words on any subject dealing with the artistic or technical side of literature, the drama, and music, are considered. *No payment* made.

AUTOCAR, *20, Tudor Street, E.C., and Coventry.*
 3d. W. (Saturday).—Articles and news relating to motors and all mechanically-propelled road carriages. *Payment* after publication.
 Illustrations: Photographs of interesting motor events.

AUTOMOTOR JOURNAL, Stanley Spooner, *44, St. Martin's Lane, W.C.*
 3d. W.—Practical and useful articles upon automobilism—illustrated for preference—are considered.

BABY, THE MOTHERS' MAGAZINE, Mrs. Ballin, *5, Agar Street, W.C.*
 4d. W.—Deals, as the name implies, with everything interesting to mothers in the practical management of infants.

BADMINTON MAGAZINE, Alfred E. T. Watson, *8, Henrietta Street, Covent Garden, W.C.*
 1s. M. (about 25th)—A magazine devoted almost exclusively to sport or subjects which interest sportsmen. Articles and stories dealing with these subjects are considered. A *preliminary letter* is desirable. *Payment* on publication. *Remarks:* Ten guineas a month offered for the best photograph of sporting interest.
 Illustrations: Photographs dealing with sport and pastimes; also occasionally black and white work.

BAILIE, *14, Royal Exchange Square, Glasgow.*
 1d. W. (Monday).—Illustrated.

BAILY'S MAGAZINE OF SPORTS AND PASTIMES, Tresham Gilbey, *9, New Bridge Street, E.C.*

1s. M. (about 26th).—Contains articles on all kinds of high-class sport, and sometimes on country house life, etc. Articles about 2,500 words and upwards. No fiction. *Payment* on publication.

Illustrations: Chiefly half-tone blocks and photos.

BANKERS' MAGAZINE, A. W. Kiddy, *London Wall, E.C.*

1s. 6d., M.—

BAPTIST TIMES AND FREEMAN, J. H. Shakespeare, *4, Southampton Row, W.C.*

1d. W.—

BAZAAR, L. Upcott Gill, *170, Strand, W.C.*

2d. Tri-weekly.—Practical articles, about 1,000 words, on any practical subject.

BIBBY'S QUARTERLY, Joseph Bibby, *Exchange Chambers, Liverpool.*

1s.—Short articles on general subjects; fully illustrated by photos.

BIBLE CHRISTIAN MAGAZINE, J. H. Batt, *26, Paternoster Row, E.C.*

4d. M.—Kind of matter desired : Of religious interest, missionary and literary, historical and expository. Length of articles preferred : two to three pages.

Illustrations: Suited to subjects; portraits, and missionary blocks.

BIG BUDGET, Arthur Brooke *(Art Editor):* "Yorick," *28, Maiden Lane, W.C.*

1d. W. (Thursday).—Dramatic stories and jokes accepted. *Payment* on publication, according to merit.

Illustrations: Line only.

BLACK AND WHITE, *63, Fleet Street, E.C.*

6d. W. (Friday).—Sketches or articles of events and people of present and passing interest, from 200 to 2,000 words are accepted. No *preliminary letter* is required.

Illustrations: Coloured cover for Christmas Number. Line, wash, and photographs to illustrate articles, or of passing events; occasional full page, line or wash.

BLACKWOOD'S MAGAZINE, William Blackwood, *37, Paternoster Row, E.C., and 45, George Street, Edinburgh.*

2s. 6d. M. (1st)—The contents chiefly bear upon sport, travel, and history, with some short stories by good writers; articles, 6,000 to 10,000 words in length. All contributions must be of a high-class character. No *preliminary letter* is necessary. *Payment:* Liberal for good work.

BOOK AND NEWS TRADE GAZETTE, Syd. H. E. Foxwell, *27 Chancery Lane, E.C.*

1d. W.—News-notes, reports, etc.

BOOK MONTHLY, James Milne, *14, Tavistock Street, W.C.*

6d.—Articles on literary subjects, and men of letters.

Illustrations: Photos.

BOOKMAN, Dr. Robertson Nicoll, *27, Paternoster Row, E.C.*

6d. M. (1st).—A literary journal with reviews and articles on literary subjects. A *preliminary letter* is generally advisable.

Illustrations: Photographs of literary interest.

BOOKSELLER, G. H. Whitaker, *12, Warwick Lane, E.C.*

6d. net. M.—

BORDER MAGAZINE, W. Sanderson, *Galashiels.*

3d.—No remuneration.

BOUDOIR, R. Lewis James, *54a, Fleet Street, E.C.*
 1s. M.—Contains articles of intimate interest to gentlewomen.
Illustrations: Photographs and wash drawings.

BOYS' AND GIRLS' MAGAZINE, Henry Pickering, *73, Bothwell Street, Glasgow.*
 ½d. M. (1st).—A high-class illustrated paper for children. Salvation stories, evangelistic articles, and illustrations of interest to children are considered. Articles should be about 500 words, and contributors should state price expected. *Payment* on acceptance.
Illustrations: Line, wash and photographs of interest to children, dealing with religious matters, Gospel addresses, great preachers, or Bible subjects. Cuts 6½ by 5in., or any less size.

BOYS' FRIEND, Hamilton Edwards, *2, Carmelite House, E.C.*
 1d. W.—Serial stories suitable for boys' reading. Good healthy adventure; sea; school; historical or foreign lands. Plenty of incident, and no elaborate verbiage. Length, 60,000 to 100,000 words. Complete stories, same style, about 10,000 words in length. All copy must be type-written.

BOYS' HERALD, Hamilton Edwards, *2, Carmelite House, Carmelite Street, E.C.*
 1d. W.—Serial stories suitable for boys' reading. Good healthy adventure; sea; school; historical or foreign lands. Plenty of incident and no elaborate verbiage. Length, 60,000 to 100,000 words. Complete stories, same style, about 10,000 words in length. All copy must be type-written.

BOYS OF THE EMPIRE, *6, West Harding Street, E.C.*
 ½d. W. (Saturday).—This journal consists mostly of stories of adventure and travel suitable for boys. Contributions should be full of incident and written in a bright, entertaining style. A *preliminary letter* is desirable. *Payment* after publication.

BOYS' OWN PAPER, George Andrew Hutchison, *4, Bouverie Street, E.C.*
 1d. and 6d., W. & M.—A magazine containing articles on games, sports, and hobbies of interest to boys. Long and short stories are acceptable, but must be bright and full of incident. Articles should be from 1,500 words, and stories rather longer. Serial stories are also accepted. No *preliminary letter* is desirable. *Payment:* From one guinea per page, upwards. *Remarks:* The number of MSS. submitted is so large that writers who are not prepared to wait their turn for consideration are advised not to send at all.
Illustrations: Cover varies; frontispiece and supplement in colour; line, wash, and photographs to illustrate stories, articles, or events of interest to boys.

BOYS' REALM, Hamilton Edwards, *Carmelite House E.C.*
 1d. W. (Saturday).—Contains serial and short stories of an exciting and adventurous character for boys. *Payment* on publication.

BRAIN, Henry Head, F.R.S., *St. Martin's Street, W.C.*
 3s. 6d. Q.—The organ of the Neurological Society of Great Britain. The kind of matter preferred consists of scientific articles, especially of neurological interest. *No payment* made.

BRITISH AND COLONIAL PRINTER AND STATIONER, G. Brown, *58, Shoe Lane, E.C.*
 2d. W.—Outside contributions not invited, unless of a very special character.

BRITISH EMPIRE REVIEW, *112, Cannon Street, E.C.*
6d. M. (1st).—Articles relating to Imperial and Colonial questions may be sent in for consideration.
Illustrations: Portraits of celebrities, past and present, who have served the Empire.

BRITISH JOURNAL OF NURSING, Mrs. Bedford Fenwick, *11, Adam Street, Strand, W.C.*
1d. W.—Entirely a professional journal, and contains details of interest to the profession; also short articles in a popular style of about 1,500 words are considered, written out of practical experience.

BRITISH MEDICAL JOURNAL, Dr. Dawson Williams, *429, Strand, W.C.*
6d. W.—

BRITISH MONTHLY, Dr. W. Robertson Nicoll, *27, Paternoster Row, E.C.*
6d. M. (25th).—An illustrated magazine, recording religious life and work. Short paragraphs are accepted.

BRITISH WEEKLY, Dr. W. Robertson Nicoll, *27, Paternoster Row, E.C.*
1d. W.—A newspaper with notes, reports, articles, etc., dealing chiefly with religious life and work.

BRITISH WORKMAN, F. Holderness Gale, *9, Paternoster Row, E.C.*
1d. M. (25th).—Articles of moderate length on industrial subjects, biography, travel sketches, all illustrated, are accepted. Contributions are not invited, and a *preliminary letter* is essential. *Payment* according to interest of article.
Illustrations: Full page, line or wash, domestic scenes; also photos of travel, or passing interest.

BROAD ARROW, *Temple House, Temple Avenue, E.C.*
6d. W. (Saturday).—A military magazine, dealing with topics interesting to Army men.

BUILDER, H. Heathcote Statham, F.R.I.B.A., *Catherine Street, W.C.*
4d. W.—Articles on architecture at home and abroad, archæological detail, etc., illustrated by line work if possible, also photos, notes, reports, etc. The magazine has a wide range.

BUILDER'S JOURNAL, H. Kempton Dyson, R. Randal Phillips, *6, Gt. New Street.*
2d. W.—The kind of matter desired is that dealing with practical construction.
Illustrations: Constructional details.

BUILDING NEWS, E. J. Kibblewhite, *Clement's House, Strand, W.C.*
4d. W.—

BUILDING WORLD, Paul N. Hasluck, *La Belle Sauvage, E.C.*
1d. and 6d. W. and M.—A purely technical and trade paper, dealing with subjects of interest to builders. Practical articles of matters connected with the trade are considered. *Preliminary letter* is not necessary.
Illustrations: Technical illustrations, line or photographs.

BURLINGTON MAGAZINE, C. J. Holmes; Robert Dell, *17, Berners Street, W.*
2s. 6d. M.—An illustrated magazine for collectors, artists, and students, dealing with all forms of art, both ancient and modern. Rate of *payment*, 30s. per page. Average length of article, 2,500-3,000 words. The Editors can use only articles written by those who have special know-

ledge of the subjects treated, and cannot accept MSS. compiled from works of reference.
Illustrations: Almost invariably made from photographs.

BYE CONES, Woodall, Minshall, Thomas and Co., *Oswestry.*
5s.—A journal devoted to the antiquarian interests of Wales and the border counties.

BYSTANDER, Comyns Beaumont, *Tallis Street, E.C.*
6d. W.—Short stories of modern setting only are accepted. These are usually illustrated. *Payment:* £2 2s. per thousand words.
Illustrations: The cover varies. Coloured supplements are a frequent feature. There are also photographs of topical subjects; line, wash, black and white, or colour full-pages, and humorous or caricature sketches.

CAMBRIAN NATURAL OBSERVER, Arthur Mee, *Llanishen, Cardiff.*
2s. 6d.—The organ of the Astronomical Society of Wales. It contains articles and notes on astronomical and natural phenomena. *No payment* for contributions.

CAPITALIST, *11-12, Clement's Lane, E.C.*
6d. W.—A weekly record of the movements of capital.

CAPTAIN, THE, R. S. Warren Bell, *Burleigh Street, Strand, W.C.*
6d. M.—A boys' magazine, containing articles, stories, etc., generally illustrated. Articles should be under 2,000 words, dealing with subjects of interest to boys. Stories should average from 2,000 to 4,000 words, and school or adventure tales are mostly required. Contributions should be brightly written, and when possible be such as may be illustrated. In the case of articles, interviews, and serial stories, a *preliminary letter* is required. *Payment* varies according to the merit of the work, and is usually a matter of arrangement. *Remarks:* Short stories of school life and adventure written by those who have a real knowledge of the subject, is what the editor chiefly requires.
Illustrations: Cover varies. Frontispiece black and white or colour, line, wash, or photograph. Full-page and article illustrations, line, wash, or photographs of interest to boys.

CAR, THE, The Hon. John Scott Montagu, M.P., *Shaftesbury Avenue, W.C.*
6d. W. (Tuesday)—Articles and paragraphs dealing with mechanical locomotion, and motor car stories are considered. No *preliminary letter* is desired.
Illustrations: Wash drawings and photos of interest to motorists.

CARADOC QUARTERLY, Gertrude Hudson, *1, Priory Gardens, Bedford Park, W.*
2s. 6d. net.—Short stories, 2,000-5,000 words; articles on art (including music), literature, picturesque travel sketches, verse, etc., will be gladly considered.
Illustrations: Etchings, drawings, non-copyright photos.

CASSELL'S MAGAZINE, Max Pemberton. *La Belle Sauvage, E.C.*
6d. M.—A journal devoted to stories and interesting topical articles. Contributors are invited to send in articles and complete short stories, which must be bright and original. A *preliminary letter* is generally desirable, particularly if the matter is to be illustrated. *Remarks:* All MSS. must be typewritten.
Illustrations: Frontispiece wash or photo. Full pages, tail pieces, stories and articles, illustrated in line or wash; also photos.

CASSELL'S SATURDAY JOURNAL, Ernest Foster, *La Belle Sauvage,*
E.C.
 1d. W. (Wednesday).—This journal always includes a serial story by a
leading writer; it also contains chatty, anecdotal articles dealing with
matters and with people of to-day; as well as interviews, miscellaneous
notes, etc. Short, clever, dramatic stories, not over 2,000 words, topical
articles of the above-named kind, which must be smart and up-to-date,
and average from 600 to 1,200 words, are gladly considered. A *prelim-
inary letter* is unnecessary. *Payment:* Articles, generally at the rate of
one guinea per column; stories, by arrangement; and the contributions
from readers printed on the last page are paid at special rates.
 Illustrations: Occasional portraits (line) or drawings of topical and
general interest.

CASSIER'S MAGAZINE, Louis Cassier, *33, Bedford Street, Strand, W.C.*
 1s. M. (1st).—A magazine containing practical articles on electricity,
steam-power, industry, etc. MSS. concerning these subjects are con-
sidered. *Payment:* One guinea per page of text.
 Illustrations: These are technical, and are line or photos.

C. B. FRY'S MAGAZINE, *12, Burleigh Street, Strand, W.C.*
 6d. net. M. (18th).—The outdoor magazine of human interest. Makes
a great feature of its illustrations. Short stories of an original and
humorous character, and possessing some outdoor interest, are always
acceptable. Most of the articles are organised from headquarters; a
preliminary letter is therefore necessary. Specimens of good and striking
photographs suitable for the magazine will always receive careful atten-
tion. *Payment* by arrangement.

CELTIC REVIEW, Professor D. Mackinnon, Miss E. C. Carmichael,
Edinburgh.
 2s. 6d. Q.—This review deals with Celtic subjects of all kinds. *No
payment* is made to contributors.

CHAMBERS'S JOURNAL, C. E. S. Chambers, *339, High Street, Edin-
burgh, and 47, Paternoster Row, E.C.*
 7d. or 8d. M.—High-class serials and short stories, and articles of
current and general interest, from 2,000 to 3,000 words in length, are
gladly considered. Stamps should be enclosed for return of unaccepted
manuscripts.

CHATTERBOX, *3, Paternoster Buildings, E.C.*
 ½d. and 3d.. W. and M.—Contributions should take the form of any-
thing interesting and healthy for children, from 8 to 15 years; length,
600 to 1,500 words; verse, 3 or 4 stanzas. No *preliminary letter* is desired.
Remarks: Contributors would do well to study the magazine itself before
sending in MSS.
 Illustrations: Cover of annual volume varies. Coloured frontispiece and
coloured plates. Ordinary numbers contain illustrations in line, wash, or
may be photos, of interest to young children.

CHEMIST AND DRUGGIST, Peter MacEwan, F.C.S., *42, Cannon
Street, E.C.*
 4d. W.—News of the trade and technical articles, or commercial in-
formation respecting the chemical and drug trades. *Payment* by arrange-
ment.

CHILDREN'S FRIEND, F. Holderness Gale, *9, Paternoster Row, E.C.*
 1d. M. (25th).—This is an illustrated magazine, entirely for children.
Biography, travel, short stoies, suitable articles, and poems, are con-
sidered. All articles should be very brief. A *preliminary letter* is essen-
tial. Contributions are not invited indiscriminately.
 Illustrations: Line, wash, and photos of interest to children.

CHILDREN'S QUARTERLY, Greenslade and Co., *Reading.*
6d. Q.—Contains articles on nature subjects suitable for children. Payment is not usually made. *Remarks:* This quarterly was started by the Reading Natural History Committee of the Parents' National Educational Union, to meet a local want. It now circulates widely, and besides articles for children it is of assistance to teachers.
Illustrations are occasionally included.

CHILD'S COMPANION, *4, Bouverie Street, E.C.*
1d. M. (25th).—An illustrated magazine for children, with stories and instructive articles. Outside contributions are occasionally accepted.

CHILD'S OWN MAGAZINE, *57, Ludgate Hill, E.C.*
½d. M.—Stories and articles suitable for illustration are considered. These should be bright, short, and simply worded, intended for children between 7 and 12 years of age. No *preliminary letter* is required.
Illustrations: Line preferred, but photos used.

CHRISTIAN, R. C. Morgan, *12, Paternoster Buildings, E.C.*
1d. W.—A weekly journal of religious intelligence from the foreign and the home fields. It contains also notes and comments on current affairs from an evangelical standpoint, expository and devotional writings, a young people's page, Sunday School Lesson Notes, etc., etc.

CHRISTIAN AGE, Jas. A. Craig, *4, St. Bride Street, E.C.*
1d. and 6d. W. and M.—A family paper, dealing chiefly with subjects of a religious nature, but containing also a serial story and some social matter. Outside contributions should take the form of articles on topics religious and social, or serial stories about 80,000 words long. It is optional to send a *preliminary letter.* Illustrated.

CHRISTIAN COMMONWEALTH, Albert Dawson, *73, Ludgate Hill, E.C.*
1d. W. (Thursday).—A paper appealing to Christian readers. It contains short and serial stories, news paragraphs, interviews, and personal sketches. MSS. of these various sorts are considered. A *preliminary letter* is advisable. *Payment* depends upon the nature of the contribution.
Illustrations: Chiefly photos.

CHRISTIAN GLOBE, *185, Fleet Street, E.C.*
1d. W. (Thursday).—Articles on religious subjects, news of all churches, tales and general articles suitable for family reading, are considered. A *preliminary letter* is not necessary.

CHRISTIAN HERALD, *6, Tudor Street, E.C.*
1d. W. (Thursday).—Any contributions of a curious, religious, or adventurous character are invited. A *preliminary letter* is only necessary in the case of a lengthy story.

CHRISTIAN LIFE, AND UNITARIAN HERALD, *5, Fetter Lane, E.C.*
1d. W. (Saturday).—Contains notes, news, a leading article, etc., interesting to all denominations of the Church.

CHRISTIAN WORLD, Herbert Clarke, *13, Fleet Street, E.C.*
1d. W. (Thursday).—News paragraphs, especially those dealing with church affairs; articles and sketches on religious, philanthropic, and general subjects; and complete stories from 1,000 to 2,500 words in length, are considered.

CHUMS, Ernest Foster, *La Belle Sauvage, E.C.*
1d. and 6d. W. and M.—A paper for boys, containing serial stories, complete stories of adventure, school life, or of a humorous character; illustrated articles, miscellaneous notes, etc. The complete stories should

be either 2,000 or 4,000 words, and articles (preferably with photo illustrations) from 700 to 1,400 words. A *preliminary letter* is unnecessary. *Payment* according to arrangement.

Illustrations: Frontispiece line, also story and article illustrations, line, wash, or photo, and humorous sketches. Photos of topical and of general interest to boys.

CHURCH AND SYNAGOGUE, Rev. W. O. E. Oesterly, *34, Southampton Street, W.C.*
6d. Q.—A Biblical and historical review, in relation to Christianity. No illustrations.

CHURCH BELLS, the Rev. Montague Fowler, *5, Tower Street, St. Martin's Lane, W.C.*
1d. W. (Friday).—This is a Church paper, giving Church news both at home and abroad. Articles on such matters, or descriptions of work, or essays on topics of current interest, are considered. A *preliminary letter* is preferred.

CHURCH FAMILY NEWSPAPER, W. N. Medlicott, *89, Farringdon Street, E.C.*
1d. W. (Thursday).—The newspaper contains articles of general or religious interest, also serial stories, but does not accept very much work from outside contributors. A *preliminary letter* is not necessary, but is advisable. Usual *payment:* For articles, one guinea; stories, by arrangement.

CHURCH QUARTERLY REVIEW, *New Street Square, E.C.*
6s.—Essays on theological and ecclesiastical subjects, also literary reviews.

CHURCH TIMES, *Portugal Street, W.C.*
1d. W. (Friday).—Church news, literary and ecclesiastical articles, are considered. A *preliminary letter* is essential.

CHURCHMAN, Rev. W. H. Griffith Thomas, B.D., *62, Paternoster Row, E.C.*
6d. M. (25th).—A journal dealing with religious and literary subjects and with the life and work of the Church generally. Articles of a character to suit the paper, theological, religious, and literary, or anything affecting the laity and clergy of the Church of England, may be sent in for consideration. These should vary from 2,000 to 5,000 words. A *preliminary letter* is required.

CITY PRESS, *148 and 149, Aldersgate Street, E.C.*
1d. W. (Wednesday and Saturday).—Contributions of an antiquarian and archæological character are invited. Terms of *payment* to be arranged with the Editor.

CIVIL SERVICE GAZETTE, *13, Fetter Lane, E.C.*
3d. W. (Saturday).—

CLARION, R. Blatchford, *72, Fleet Street, E.C.*
1d. W. (Friday).—No articles accepted unless by special contract. No illustrations.

CLASSICAL REVIEW, J. P. Postgate *(54, Bateman Street, Cambridge); 57, Long Acre, W.C.*
1s. 6d. M.—

COLLIERY GUARDIAN, *30 and 31, Furnival Street, E.C.*
5d. Q. (Friday).—As the journal is devoted exclusively to colliery matters, only trade articles of special value need be offered by outside contributors. A *preliminary letter* is generally advisable.

COMIC LIFE, *Red Lion Court, Fleet Street, E.C.*
½d. W. (Thursday).—This journal contains comic pictures, serials, and short stories of an amusing nature. Only serial stories are required from outsiders, and a *preliminary letter* should be sent first.
Illustrations: Humorous line.

COMMERCIAL INTELLIGENCE, Henry Sell, *166, Fleet Street, E.C.*
3d. W.—This journal contains articles and information likely to be of practical value to British business men. Such articles are welcome, but the writers should give the Editor some indication that their information is authentic. *Remarks:* No theoretical, political, or economic treatises are required.
Illustrations: Occasional line drawings.

COMMONWEALTH, Canon Scott Holland, *3, Paternoster Buildings, E.C.*
3d. M. (25th).—A journal dealing with matters social, religious, literary, or artistic. Fiction is not required. A *preliminary letter* is advisable.

CONNOISSEUR, J. T. Herbert Bailey, *95, Temple Chambers, E.C.*
6d. M. (1st).—Articles on all subjects interesting to collectors are considered, but a *preliminary letter* must be sent. *Remarks:* Authors are held responsible for all dates and facts mentioned.

CONTEMPORARY REVIEW, Percy W. Bunting, *11, Endsleigh Gardens, Euston, W.C.*
2s. 6d. M. (1st).—A review dealing with all questions of the day, chiefly politics, science, history, literature. Articles of a character to suit the journal are occasionally accepted by the Editor, but the greater part of the work is commissioned. A *preliminary letter* is always required.

CORNHILL MAGAZINE, Reginald J. Smith, K.C., *15, Waterloo Place, S.W.*
1s. M. (26th).—A high-class journal, containing short stories and articles. Stories of about 4,500 words are frequently accepted, and some articles. All contributions are attentively considered, and unaccepted MSS. are returned when accompanied by stamps for postage. MSS. cannot be delivered on personal application, nor must they be forwarded through the post when only initials are given. Every contribution should be typewritten. *Payment:* One guinea per page (each page contains about 425 words).

COTTAGER AND ARTISAN, *4, Bouverie Street E.C.*
1d. M. (25th).—A popular illustrated magazine for the working man and his family, with practical instructions on gardening, poultry keeping, how to prepare cheap and nourishing dinners, etc.: in fact, every phase of industrial life. Outside contributions occasionally accepted.
Illustrations: Cover varies.

COUNTRY LIFE, P. Anderson Graham, *Tavistock Street, Covent Garden, W.C.*
6d. W. (Saturday).—An illustrated journal, chiefly concerned with sports and the country. No contributions need be submitted that are not really suitable for the paper, and of considerable merit. A *preliminary letter* is desirable.
Illustrations: Cover varies occasionally for special numbers. Photos of travel and country life. No drawings.

COUNTRY-SIDE, E. Kay Robinson, *2 and 4, Tudor Street, E.C.*
1d. W.—Country topics, original observations in natural history, stories of animals, etc., from the staple material. Length of articles, 500 to 1,000 words.
Illustrations: Photographs.

COUNTY COURTS CHRONICLE, Basil Crump, *Bream's Buildings, E.C.*
1s. 6d. M.—

COUNTY GENTLEMAN, AND LAND AND WATER, Eric Parker, *4 and 5, Dean Street, Holborn, W.C.*
6d. W. (Saturday).—Articles, news paragraphs, photos, and sketches of sporting interest are considered by the Editor, articles about 1,500 words in length. A *preliminary letter* is desirable. *Remarks:* There are acrostic prizes.
Illustrations: Photos, which should accompany articles whenever possible.

COURT CIRCULAR, D. S. Hunter, *150, Strand, W.C.*
6d. W. (Saturday).—Contains light, short stories of society nature, personal interviews and social matters of general interest. All contributions should be bright and amusing, and likely to be interesting to society people. A *preliminary letter* is not necessary, but desirable. *Remarks:* The editor does not depend on outside contributions, but is willing to consider them, and return them if unsuitable.

COURT JOURNAL, General Maxwell, *13, Burleigh Street, W.C.*
6d. W. (Saturday).—This paper contains social, Service, and sporting news. Dramatic dialogues, in which the "stage directions" should be indicated in the fewest possible words, are invited. Light articles on holiday and health resorts are also acceptable. Short stories only appear in the special Christmas Number, and no illustrated matter can be inserted. Notes on the Navy will always be considered, when properly authenticated. No *preliminary letter* is necessary.

CRANK, F. E. Worland, *3, Amen Corner, E.C.*
1d. M.—

CRITICAL REVIEW OF THEOLOGICAL AND PHILOSO-PHICAL LITERATURE, *14, Henrietta Street, W.C.*
1s. 6d. Bi-Monthly.

CYCLING, W. Groves, *Rosebery Avenue. E.C.*
1d. W.—Matter from outside sources only accepted to a very small extent, and is not invited by the editor.

CYCLISTS' TOURING CLUB GAZETTE, E. R. Shipton, *47, Victoria Street, S.W.*
M. (1st).—This journal contains articles and news interesting to cyclists. Contributions, either artistic or literary, are considered, but no stories are accepted. Articles should deal with technical matters relating to cycles, or with tours and travel. A *preliminary letter* is required. *Payment:* 10s. 6d. to 21s. per 1,000 words.

DAILY CHRONICLE, Robert Donald, *31, Whitefriars Street, E.C.*
½d. D.—Occasional articles of current interest are accepted from outside contributors. No *preliminary letter* is required. *Payment* depends upon merit, usually about one guinea for a thousand words.
Illustrations: Occasional sketches or photos of special current interest; also fashions.

DAILY EXPRESS, C. Arthur Pearson, *Tudor Street, E.C.*
½d. D.—Articles on current topics and of general interest are acceptable, especially such as are suitable for the magazine page. No *preliminary letter* is desirable. *Payment:* Usually one guinea for 1,000 words.

DAILY GRAPHIC, T. Heath Joyce; Hammond Hall, *Milford Lane, W.C.*
1d. D.—Articles of topical interest, and news paragraphs, may be sent in for consideration. No article should exceed 900 words.
Illustrations: Topical photos and sketches; also fashions.

DAILY MAIL, T. Marlowe, *Carmelite House, E.C.*
½d. D.—News paragraphs of special interest and articles of general interest are considered, also serial stories. A *preliminary letter* is not desired, except in the case of serials. *Payment:* Usually one guinea for 1,000 words.

DAILY MIRROR, H. H. Fyfe, *12, Whitefriars Street, E.C.*
½d. D.—

DAILY NEWS, A. G. Gardiner, *20, Bouverie Street, E.C.*
½d. D.—News paragraphs and occasional articles on topics of current interest are accepted. No *preliminary letter* required. *Payment:* Usually one guinea 1,000 words.

DAILY TELEGRAPH, J. M. Le Sage, *141, Fleet Street, E.C.*
1d. D.—Special news paragraphs and articles of general interest on current topics are accepted. No *preliminary letter* required. *Payment* varies from about one guinea per 1,000 words upwards.

DAINTY NOVELS, Mrs. Thorne, *11, Gough Square.*
1d. W. (Thursday).—Contains two complete novels, fashion hints, and Society news. Contributions should be about 16,000 words. Simple, pathetic stories preferred, but very strong love interest is essential.

DAWN OF DAY, S.P.C.K., *Northumberland Avenue, W.C.*
½d. M. (1st).—Contains religious teaching, a serial story of a domestic character, and miscellaneous stories. The stories sent should be such as may be easily illustrated, and should average about 3,000 words in length. A *preliminary letter* is preferred.
Illustrations: In line.

DAY OF DAYS, Rev. C. Bullock, *11, Ludgate Square, E.C.*
1d. M. (25th).—A Sunday magazine for every home, with illustrations. Contributions should be suitable for family and Sunday reading. A *preliminary letter* is not necessary.

DRAPER, *148 and 149, Aldersgate Street, E.C.*
1d. W.—The Editor is always open to consider articles of trade interest at usual rates of payment.

DUBLIN JOURNAL OF MEDICAL SCIENCE, *41, Grafton Street, Dublin.*
2s. M. (1st).—Illustrated.

DUBLIN REVIEW, Canon Moyes, *28, Orchard Street, W.*
6s. Q.—A Roman Catholic magazine, dealing with history, literature, theology, etc., from that standpoint; articles should be well thought out and of value, and should run from 3,000 to 11,000 words.

ECONOMIC JOURNAL, F. Y. Edgeworth, Henry Higgs, *St. Martin's Street, W.C.*
5s. Q.—

ECONOMIC REVIEW, Rev. J. Carter, M.A., Rev. H. Rashdall, M.A., D.Litt., H. A. Prichard, M.A., *Oxford.*
3s. Q.—Articles on social and economic subjects. Length from 3,000 to 6,000 words. No remuneration.

ECONOMIST, Edward Johnstone, *Granville House, Arundel St., W.C.*
8d. W.—

EDINBURGH REVIEW, *39, Paternoster Row, E.C.*
6s. Q.—This quarterly is especially well-known for political articles and reviews of books. It accepts very little work from outside contributors, but reviews and articles likely to be of interest to the public may be submitted. These should be on literary, historical, political, and travel subjects. A *preliminary letter* is in all cases required.

EDUCATION, *24, Bride Lane, E.C.*
3d. W. (Thursday).—

EDUCATIONAL NEWS, *40, Princes Street, Edinburgh.*
1d. W. (Friday).—

EDUCATIONAL TIMES, Dr. A. F. Murison, *89, Farringdon Street, E.C.*
6d. M. (1st).—This journal deals with all matters educational. Articles on such subjects are welcome, special interest being taken in those that treat in some way of secondary or higher education. The length should be from 1,000 to 2,000 words. A *preliminary letter* is of no use, as work is accepted or declined on its merits and suitability. *Payment* by arrangement, and only moderate.

ELECTRICAL REVIEW, T. E. Gatehouse, H. Alabaster, *4, Ludgate Hill, E.C.*
4d. W.—

ELECTRICIAN, F. C. Raphael, *1, Salisbury Court, E.C.*
6d., W.—Contains articles on electrical engineering and electrical science, by engineers and physicists of high standing.

ELECTRICITY, Sidney Rentell, A.M.I.E.E., *36, Maiden Lane, W.C.*
1d. W.—An electro-technical journal. Length of articles preferred, about 1,000 to 1,500 words. *Payment:* 5s. per column.
Illustrations: From blocks of either line or tone.

EMPIRE BOUQUET NOVELS, *6, West Harding Street, E.C.*
1d. W. (Thursday).—This weekly consists of one long complete novel. Stories of this kind may be sent in for consideration. They should be about 20,000 words, must be dramatic, full of interest, and brightly written.

EMPIRE REVIEW, C. Kinloch Cooke, *St. Martin's Street, W.C.*
1s. M.—

ENGINEER, *33, Norfolk Street, Strand, W.C.*
6d. W. (Friday).—

ENGINEERING, *36, Bedford Street, Strand, W.C.*
6d. W. (Friday).—

ENGINEERING MAGAZINE, *222-5, Strand, W.C.*
1s. M. (1st).—This journal is entirely devoted to the interests of engineers. Articles relating to engineering are usually acceptable but must have a technical or commercial interest. The average length is from 3,000 to 4,000 words. A *preliminary letter* should certainly be sent. *Remarks:* Contributions, which do not show a special knowledge on the part of the writer, have no chance of acceptance.
Illustrations: Photos and diagrams of interest to engineers only inserted in connection with articles.

ENGINEERING REVIEW, C. Edgar Allen, *104, High Holborn.*
 6d. M.—

ENGINEERING TIMES, *Orchard House, Westminster, S.W.*
 2d. W. (Thursday).—This journal contains articles dealing with civil, mechanical, or electrical engineering, and trade. Contributions should be about 1,000-2,000 words in length. A *preliminary letter* is desirable. *Remarks:* MSS. are received from every part of the globe.
 Illustrations: Technical; half-tone blocks.

ENGLISH MECHANIC, E. J. Kibblewhite, *Clement's House, Clement's Inn Passage, W..C*
 2d. W.—

ENGLISH ILLUSTRATED MAGAZINE, Oscar Parker, *358, Strand, W.C.*
 6d. M.—Articles and short stories, from 1,500 to 7,000 words, are considered. *Payment:* A guinea per 1,000 words. *Remarks:* MSS. should be typed, and stamped envelope must be enclosed. No poetry of over 60 lines need be submitted.
 Illustrations: Cover varies. Frontispiece and full pages in line, wash, or photos.

ENGLISH HISTORICAL REVIEW, R. L. Poole, *39, Paternoster Row, E.C.*
 5s. Q.—This journal contains reviews and high-class articles, such as are usually found in quarterlies. Contributions are only accepted from writers who have a special knowledge of their subject.

ENGLISH REVIEW, T. W. H. Crosland, *180, Fleet Street, E.C.*
 6d. W.—Its columns are devoted to politics, literature, art, and similar matters.

ENGLISHWOMAN'S REVIEW, Antoinette M. Mackenzie, *22, Berners Street, W.*
 1s. Q.—A publication dealing with the social and industrial progress of women in all parts of the world. No fiction admitted. Length of articles 1,000 to 2,000 words, on subjects dealing with women's work, suffrage, industrial questions, etc., in England and abroad. Education and training of children. Reviews of books concerning women and children. Biographies of women. *No payment* is made. There are no illustrations.

ENTOMOLOGISTS' MAGAZINE, Commander J. J. Walker, R.N., and others, *10, Paternoster Row, E.C.*
 6d. M.—

ERA, T. P. O'Connor, Frank Desprey, *Era Buildings, W.C.*
 6d. W. (Saturday).—

ESTATES GAZETTE, William Robinson, *6, St. Bride Street, E.C.*
 3d. W.—

EVANGELICAL BRITISH MISSIONARY, D. Burford Hooke, *62, Paternoster Row, E.C.*
 1d. Q.—

EVENING NEWS, W. J. Evans, *5, Carmelite House, E.C.*
 ½d. D.—Contains short stories, articles of current interest, and news paragraphs. A *preliminary letter* is not necessary. *Payment:* From one guinea per 1,000 words upwards.

EVERY BOY'S MONTHLY, *4, Bouverie Street, E.C.*
1d. M.—A popular high-class magazine for boys, somewhat similar in scope and conditions to the *Boys' Own Paper*, and conducted by the same Editor.

EVENING STANDARD AND ST. JAMES'S GAZETTE, *104, Shoe Lane, E.C.*
1d. D.—Short articles of general interest are considered. *Payment:* £1 10s. per article, and upwards.
Illustrations: Fashion drawings for ladies' page.

EXAMINER (THE CONGREGATIONAL WEEKLY), Rev. W. B. Selbie, *13, Memorial Hall, E C.*
1d. W.—

EXPOSITOR, Dr. Robertson Nicoll, *27, Paternoster Row, E.C.*
1s. M.—

EXPOSITORY TIMES, Dr. James Hastings, *38, George Street, Edinburgh.*
6d. M.—

FAMILY FRIEND, F. Holderness Gale, *8, Paternoster Row, E.C.*
1d. M. (25th).—Articles of semi-religious interest are mostly required, and some short stories, travel articles, and personal sketches, are also accepted; anything with a strong domestic appeal favourably considered. A *preliminary letter* is required.
Illustrations: Line and wash of domestic interest.

FAMILY HERALD, *23, Henrietta Street, W.C.*
1d. W. (Wednesday).—Articles are required on all subjects of general interest, also fiction, both short stories and serials. *Remarks:* Editor takes all possible care to ensure safe return of rejected MSS., where stamps are enclosed. The numbers of MSS. submitted for consideration being very large, several weeks has sometimes elapsed before the Editor's decision can be communicated to authors. *Payment* on acceptance.

FAMILY HERALD SUPPLEMENT, *23, Henrietta Street, W.C.*
1d. W. (Monday).—Complete novel of a character to suit this paper is always gladly considered. *Payment* on acceptance.

FAMILY POCKET STORIES, *23, Henrietta Street, W.C.*
1d. W. (Tuesday).—Contributors may send complete stories from 2,000 to 10,000 words. Payment is made on acceptance. No *preliminary letter* required.

FAMILY STORY TELLER, *23, Henrietta Street, W.C.*
1s. (published according to announcement).—Contains a complete novel of 100,000 words and upwards. Contributors may send in MS. answering to this description. *Payment* on acceptance.

FARM AND GARDEN, T. W. Sanders, *148 and 149, Aldersgate Street, E.C.*
1d. W. (Saturday).—A journal devoted to the interests of dairying, dairy cattle, live stock breeding, general farming, poultry farming, market gardening, bee-keeping, household and rural industries generally. Scientific and practical articles only, written by experts in above industries, required. Stamped addressed envelope to be enclosed with manuscript for return, in case of rejection.
Illustrations: Photographs of farm and rural life; also animals.

FARM AND HOME, W. Robinson, *17, Furnival Street, E.C.*
1d. W. (Saturday).—The contents of this magazine deal entirely with farming, dairy-work, and household subjects. Articles on these and kindred matters are frequently accepted, but must be practical. A *preliminary letter* is desirable. *Payment* at the rate of 12s. per column.

FARM, FIELD AND FIRESIDE, A. W. Stanton, *1, Essex Street, W.C.*
1d. W. (Friday).—An illustrated paper, containing news, notes, and articles on country life. Contributions sent should be suitable for illustration. A *preliminary letter* is not required.
Illustrations: Line and photos, illustrating animal and country life.

FEATHERED WORLD, Mrs. Comyns-Lewer, *9, Arundel Street, W.C.*
1d. W. (Friday).—An illustrated journal, containing news and articles on all subjects connected with poultry and pigeons. Articles on such topics are acceptable, but should be written by those who understand the subject. A *preliminary letter* is required.
Illustrations: Line, wash, and photos of bird life.

FIELD, William Senior, *Breams Buildings, E.C.*
6d. W. (Saturday).—This journal contains articles or news concerning sports, country pursuits, natural history; also biographical sketches of leading patrons of field sports. A *preliminary leter* is desirable.

FINANCIAL NEWS, H. H. Marks, *11, Abchurch Lane, E.C.*
1d. D.—

FINANCIAL TIMES, A. E. Murray, *72, Coleman Street, E.C.*
1d. D.—

FINANCIER AND BULLIONIST, *21 and 25, Dean Street, E.C.*
1d. D.—

FIRESIDE NOVELIST, *158, Fleet Street, E.C.*
1d. W. (Wednesday).—Contains two complete stories in each number, about 18,000 words. MSS. of general interest, full of incident, and treated dramatically are gladly considered. A *preliminary letter* is preferred, and the synopsis of the story may be submitted on approval. Contributors should state what remuneration they desire.

FISHING GAZETTE, R. B. Marston, *St. Dunstan's House, Fetter Lane, E.C.*
2d. W. (Friday).—Any articles describing where good angling can be obtained may be sent, also good articles on sport, notes, reports, etc., but a *preliminary letter* is desirable.
Illustrations: Mainly photographs.

FOLK LORE, Miss C. S. Burne, c/o D. Nutt, *57, Long Acre, W.C.*
5s. Q.—The organ of the Folk-lore Society. Communications from non-members containing first-hand records of observed facts of folk-lore, folk-tales, not previously recorded, or in languages little known, etc., are accepted for publication. No *payment* is offered for contributions. Reviews of works on folk-lore form a special feature.

FOOTBALL CHAT, E. C. Price, *5 and 6, Johnson's Court, Fleet Street, E.C.*
1d. W. (Monday).—A popular athletic paper, with football stories and illustrations.

FORE'S SPORTING NOTES AND SKETCHES, *41, Piccadilly, W.*
2s. Q.—An illustrated magazine containing articles on sporting matters, and sporting stories, with pen and ink full-page illustrations. No *preliminary letter* required. *Payment* on acceptance.

FORGET ME-NOT, Laurence Clarke, *Carmelite House, E.C.*
1d. W. (Thursday).—A paper containing short stories, articles on domestic matters, and news. Short stories should be either 1,700 or 7,500 words, and must have a love interest. Articles and paragraphs on household subjects may also be sent. *Payment* usually at the rate of one guinea per page.

FORTNIGHTLY REVIEW, W. L. Courtney, *11, Henrietta Street, Covent Garden, W.C.*
2s. 6d. M. (28th).—A high-class review, containing articles of current interest on literary, political, and social affairs. Only really good work should be submitted, and articles should be from 4,000 to 7,000 words in length. *Remarks:* A *preliminary letter* is not required, but is of considerable convenience to the Editor.

FREE CHURCH CHRONICLE, Herbert D. Williams, *Memorial Hall, E.C.*
2d. W.—Official organ of the National Free Church Council. Only matter of Free Church interest inserted.

FREE CHURCHMAN, Herbert D. Williams, *Memorial Hall, E.C.*
1d. W.—Magazine for localising. Exhaustive programme by leading Free Churchmen made up annually, in July, but short stories (2,000 words) and general illustrated articles occasionally accepted from outsiders.

FRIEND, H. Stanley Newman, *Leominster.*
1d. W.—Weekly organ of the Society of Friends in the United Kingdom.

FRIENDLY GREETINGS, *4, Bouverie Street, E.C.*
½d. and 4d. W. and M.—Contains illustrated stories from real life, with morals, religious articles of an undenominational character, specially prepared with a view to distribution in the homes of the people.
Illustrations: Cover varies.

FRUIT GROWER, FRUITERER, FLORIST, AND MARKET GARDENER, G. Tucker, *1, 2 and 3, Salisbury Court, E.C.*
1d. W.—

FURNITURE RECORD, Herbert E. Binstead, *14, City Road, E.C.*
2d. W.—Kind of matter taken—anything of trade interest.
Illustrations: Half-tone or line.

GAINSBOROUGH NOVELS, *158, Fleet Street, E.C.*
½d. W. (Saturday).—Two complete stories are contained in each number. Stories or novels brightly written and of interest to ladies may be sent. A *preliminary letter* is desirable.

GARDEN, E. T. Cook, *Tavistock Street, Covent Garden, W.C.*
1d. W. (Friday).—A magazine devoted entirely to gardening and agriculture. Articles concerning these subjects, also horticulture, pasture, and the woodlands, may be sent. A *preliminary letter* is not necessary.

GARDENER, G. Tucker, *1, 2 and 3, Salisbury Court, E.C.*
1d. W.—A practical paper for all interested in gardening. Short, practical articles on matters connected with this subject are considered. A *preliminary letter* is not necessary.
Illustrations: Line and photos; fancy headings.

GARDENER'S CHRONICLE, Dr. M. T. Masters, F.R.S., *41, Wellington Street, W.C.*
3d. W.—

GARDENERS' MAGAZINE, George Gordon, *148 and 149, Aldersgate Street, E.C.*
2d. W. (Saturday).—Short notes on horticultural events, and articles on practical and scientific gardening, from 100 to 600 words, are considered.
Illustrations: Photographs of noteworthy plants and garden scenes.

GARDENING ILLUSTRATED, W. Robinson, *17, Furnival Street, E.C.*
1d. W. (Wednesday).—A paper devoted to the interests of horticulturists. Articles or notes on fruit, flowers, vegetables, indoor or outdoor plants, birds, bees, and poetry are gladly considered. A *preliminary letter* is preferred.

GARDENING WORLD, *37 and 38, Shoe Lane, E.C.*
1d. W. (Wednesday).—An illustrated journal dealing with all matters connected with horticulture. It is very seldom that space is available for outside contributions. *Remarks:* There is a weekly competition, with prizes from 10s. and under.
Illustrations: Photos.

GAS WORLD, James Stewart, *3, Ludgate Circus Buildings, E.C.*
3d. W.—

GENEALOGICAL MAGAZINE, Mr. Bannerman, *62, Paternoster Row, E.C.*
1s. M. (25th).—This journal is devoted to all matters devoted to genealogy, heraldry, monuments, etc. Articles of family history, old legends, records, parish registers, monuments, brasses, and kindred subjects, are considered. Contributions should be short, and a *preliminary letter* is unnecessary. *Payment:* Only for special work. The greater part is contributed "con amore."

GENERAL PRACTITIONER, A. P. Allan, M.D., *Moorgate Station Chambers, E.C.*
3d. W.—*Kind of matter desired:* Medical, surgical, or scientific bearing on these. *Payment* not made.

GENTLEMAN'S JOURNAL, W. Browning Hearnden, *104, Tollington Park, N.*
1s. W.—MSS. from outside contributors, at sender's risk.

GENTLEMAN'S MAGAZINE, Sylvanus Urban, *111, St. Martin's Lane, W.C.*
1s. M. (28th).—This journal contains articles of general interest, and some short stories. Both should range from 4,000 to 7,000 words. A *preliminary letter* is not necessary.

GENTLEWOMAN, J. S. Wood, *70, Long Acre, W.C.*
6d. W. (Thursday).—An illustrated journal, chiefly concerned with matters of interest to women. Contributions should take the form of short stories, and articles on current subjects, about 1,000 words in length. *Payment* varies from one guinea per column upwards. *Remarks:* Idle gossip is not wanted, and news must be authenticated.
Illustrations: Cover designs for special numbers. Line, wash, and photos to illustrate stories and articles; also fashions and needlework designs.

GEOLOGICAL MAGAZINE, *37, Soho Square, W.*
1s. 6d. net. M. (1st).—Original articles, containing the results of independent research by experts.

GIRLS' FRIEND, Hamilton Edwards, *2, Carmelite House, Carmelite Street, E.C.*
1d. W.—Serial novels of 60,000 to 100,000 words in length. Complete stories of 6,000 words, written in bright and popular style. All copy must be typewritten.

GIRLS' OWN PAPER, *4, Bouverie Street, E.C.*
1d. and 6d. W. and M.—This magazine contains stories and articles of interest to girls. Those of a domestic character generally preferred. Articles and short tales should be about a page and a half long. A *preliminary letter* is not necessary.
Illustrations: Cover varies. Frontispiece, full pages, tail pieces, story, article and verse illustrations in line, wash, and photos; also fashions.

GIRLS' REALM, S. H. Leeder, *7, New Court, Carey Street, W.C.*
6d. M. (15th).—An illustrated magazine, devoted entirely to the interests of girls. Contains a good deal of fiction. No *preliminary letter* is required. *Remarks:* Everything is done to keep contributors waiting as short a time as possible.
Illustrations: Cover varies. Frontispiece, full pages, tail pieces, article and story illustrations in line, wash and photos; also fashions.

GLOBE, G. E. Armstrong, *367, Strand, W.C.*
1d. D.—Articles of general interest, about 1,200 words, are considered. *Payment:* From one guinea and upwards.

GOLDEN STORIES, Hartley Aspden, *Carmelite House, E.C.*
1d. W. (Thursday).—Long complete story, about 20,000 words, is the chief feature of this paper—paid for at high rate.
Illustrations: In line.

GOLDEN SUNBEAMS, *S.P.C.K., Northumberland Avenue, W.C.*
1d. M. (1st).—Contains stories of a religious nature suitable for young children. These should be about 1,000-1,500 words in length, and either be illustrated in line or suitable for illustration. As outside contributions are not invited, a *preliminary letter* is always advisable.

GOLFING, Arthur E. Chadwick, *17, Bouverie Street, Fleet Street, E.C.*
1d. W. (Thursday).—The paper is the organ of the game in the British Isles.

GOOD WORDS, Rev. Dr. Donald Macleod, *2, Carmelite House, Carmelite Street, E.C.*
6d. M.—This magazine contains articles and stories, also serial tales. The serial tales are by arrangement; short stories and articles of about 3,000 words on general subjects, travel, and scriptural matters, may be sent for consideration. A *preliminary letter* is not advisable.

GRAND MAGAZINE, A. Anderson, *Southampton Street, Strand, W.C.*
4½d. net. M.—A non-illustrated magazine, containing articles and stories of the highest class. Short, vigorously-written articles, of about 3,000 words, describing out-of-the-way phases of life and manners, of interest to the general reader, or to large sections of the community, always receive consideration. Suggestions for articles are accepted, and, if adopted, are liberally paid for.

GRAPHIC, T. Heath Joyce, *190, Strand, W.C.*
6d. W. (Friday).—An illustrated weekly, containing articles on current subjects, short stories, and serials. Articles and short stories may be submitted on approval, but should have considerable merit. A *preliminary letter* is not necessary.

GREAT THOUGHTS, Rev. R. P. Downes, LL.D., *4, St. Bride Street, E.C.*

1d. and 6d. W. and M.—A paper dealing with literary and religious matters. Articles of about 2,000 words on these subjects are considered. A *preliminary letter* is optional. *Remarks:* Only articles of permanent value are likely to be accepted.

Illustrations: Line, wash, or photo illustrations of literary or artistic interest.

GROCER, *Eastcheap Buildings, E.C.*

4d. W. (Saturday).—This journal is devoted entirely to the trade, and the only contributions ever accepted are important trade articles or news.

GUARDIAN, J. Penderel-Brodhurst, *5, Burleigh Street, W.C.*

3d. W. (Wednesday).—A paper dealing with affairs generally, but chiefly with matters theological, literary, and scholastic. Contributions of a kind to suit the paper are always considered by the Editor. A *preliminary letter* is advisable.

HALFPENNY COMIC, *13, Farringdon Avenue, E.C.*

½d. W. (Tuesday).—This paper contains short stories, from 2,000 to 5,000 words, and serials, adventures, sensational jokes, and comic pictures. Contributions of this kind may be sent.

Illustrations: Line.

HALFPENNY SURPRISE, *6, West Harding Street, E.C.*

½d W. (Friday).—Contains one long complete story of adventure or school life for boys' reading, about 20,000 words in length.

HAPPY HOUR SERIES OF STORIES, *23, Henrietta Street, W.C.*

1d. W. (Thursday).—This contains fiction only, not illustrated. Contributions may be sent on approval, and no *preliminary letter* is necessary.

HEALTH RESORT, *83, Great Titchfield Street, W.*

6d. M.—Contains short articles on health resorts, and holiday tours. These should be about 1,000 words, and illustrated, if possible with good photographs of health resorts—particularly little-known ones abroad. *Remarks:* Stamped addressed envelope to be enclosed for return if unsuitable.

HEARTH AND HOME, Mrs. C. S. Peel, *10, Fetter Lane, E.C.*

3d. W. (Tuesday).—This journal contains articles of interest to women from 750 to 1,300 words; short stories, 2,000 words, are occasionally used. A *preliminary letter* is desirable. *Payment:* About 10s. to 15s. per column.

Illustrations: Cover designs for special numbers. Stories and articles illustrated by line, wash, or photos. Occasional full page. Tail pieces. Fashions and needlework designs.

HELPING WORDS, James A. Craig, *4, St. Bride Street, E.C.*

1d. M. (25th).—Articles suitable for a family magazine are considered. These should be illustrated. A *preliminary letter* is preferred. *Payment* on acceptance. *Remarks:* The magazine is specially prepared for localising by the Free Churches.

Illustrations: Photos, line or wash drawings, of religious interest.

HIBBERT JOURNAL, Prof. L. P. Jacks, *14, Henrietta Street, W.C.*

2s. 6d. net. Q.—A review of religion, theology, and philosophy, articles 3,000 to 7,000 words.

HIVE TRADE REVIEW, Herbert E. Binstead, *14 City Road, E.C.*

1d. W.—

HOME AND COLONIAL MAIL, Arthur H. Wheeler, *Temple Chambers, Temple Avenue, E.C.*
6d. W.—

HOME CHAT, *Carmelite House, E.C.*
1d. W. (Tuesday).—A paper containing Society notes, illustrated practical articles, stories, etc., of interest to ladies. Articles on household matters, and short stories of intense love interest, from about 1,500 to 2,000 words, may be sent. The articles should be 1,000 words and upwards.

HOME CIRCLE, Laurence Clarke, *Carmelite House, E.C*
1d. W. (Friday).—Several short stories and two serials. The short stories should be about 5,000 words, and should deal with thrilling situations in a practical setting, love interest essential. They should be brightly written, with no padding. *Payment:* At the rate of one guinea per page.

HOME COMPANION, Hartley Aspden, *Carmelite House, E.C.*
1d. W. (Monday).—Contains a long story of domestic love interest. Fashions and recipes, and home management.
Illustrations: Photo, line and wash.

HOME COUNTIES MAGAZINE, E. B. Lupton, M.A., *20, Gt. Russell Street, W.C.*
1s. 6d. net. Q.—A magazine containing articles on the history, literature, and science of the home counties and London. A *preliminary letter* is required.

HOME LIFE MAGAZINE, *8, Johnson's Court, Fleet Street, E.C.*
1d. M. (1st).—A family magazine, containing stories of domestic interest and useful articles. Such contributions may be sent on approval. No *preliminary letter* is desired.
Illustrations: Story and article illustrations in line, photos; also fashions.

HOME NOTES, *Henrietta Street, W.C.*
1d. W. (Friday).—Contributions should take the form of stories about 4,000 words in length, or articles of domestic interest. Serial stories are occasionally accepted. A *preliminary letter* is not necessary.
Illustrations: Cover varies, frontispiece, tail pieces, story and article illustrations in line, wash, or photos; also fashions and needlework designs.

HOME MESSENGER, F. A. Atkins, *Temple House, Temple Avenue, E.C.*
1d. M.—Contains a serial story, short stories and articles, notes, etc.; stories should not exceed 2,000 words, articles 1,000 to 1,500. Stories should have a high moral tone.

HOME STORIES, *158, Fleet Street, E.C.*
1d. W.—Contains two long complete stories of 16,000 to 18,000 words.

HOME WORDS, Rev. Charles Bullock, *11, Ludgate Square, E.C.*
1d. M. (25th).—An illustrated family magazine, containing stories of a religious character, and articles of general interest. Stories up to about 5,000 words, articles about 2,000. A *preliminary letter* is required.
Illustrations: In line; photos, etc.

HOMEWARD MAIL, Edward J. Sharpe, *65, Cornhill, E.C.*
6d. W.—

HOMILETIC REVIEW, I. K. Funk, *44, Fleet Street, E.C.*
1s. M.—

HOMŒPATHIC WORLD, Dr. J. H. Clarke, *12, Warwick Lane, E.C.*
6d. M. (1st).—A medical journal designed to serve both lay and medical readers. All contributions are voluntary.

HORNER'S PENNY STORIES, Hartley Aspden, *Carmelite House, E.C.*
1d. W. (Monday).—A higher price is paid for stories in this periodical than any other story-journal. Stories average 18,000 words, and each story is illustrated in line.

HORNER'S POCKET LIBRARY, Hartley Aspden, *Carmelite House, E.C.*
1d. (Wednesday).—Long complete story, 16,000 words, well paid for.

HORNER'S WEEKLY, Hartley Aspden, *Carmelite House, E.C.*
1d. W. (Tuesday).—Full of religious interest—articles, stories, reminiscences of ministers, biographical articles, etc. One short story (4,000) and one serial (100,000). All paragraphs and articles paid for.

HOSPITAL, Sir H. C. Burdett, K.C.B., *28, Southampton Street, Strand, W.C.*
3d. W. (Thursday).—

HUMANE REVIEW, Henry S. Salt, *York House, Portugal Street, W.C.*
1s. Q.—Articles on humanitarian subjects.

HUMANITARIAN, *53, Chancery Lane, E.C.*
1d. M. (1st).—Notes, short articles (about 1,000 words), on subjects relative to the treatment of animals.

IBIS, P. L. Sclater and A. H. Evans, *3, Hanover Square, W.*
8s. Q.—

IDLER, Robert Barr, *33, Henrietta Street, Strand, W.C.*
6d. M.—The contents of this magazine are light and bright stories and sketches, also poems. The stories should be from 1,500 to 4,000 words in length. No *preliminary letter* is necessary.
Illustrations: Line or wash preferred; photos for articles; tail pieces.

ILLUSTRATED BITS, *158, Fleet Street, E.C.*
1d. W. (Wednesday).—Contains dialogues, short stories of about 1,500 words, and paragraphs of general interest. No *preliminary letter* is necessary. *Payment:* On acceptance.

ILLUSTRATED FAMILY NOVELIST, *158, Fleet Street, E.C.*
1d. W. (Thursday).—Each number contains a long novel, and contributions should be suitable for ladies. A *preliminary letter* is certainly required.

ILLUSTRATED LONDON NEWS, Bruce S. Ingram, *198, Strand, W.C.*
6d. W. (Friday).—An illustrated newspaper, dealing chiefly with current events of general interest, and containing occasional short stories. Stories are usually accepted only from authors of established repute. No *preliminary letter* is required. *Remarks:* MSS. of poetry can in no case be returned.
Illustrations: Photos of all kinds, if of topical interest; also rough sketches. Finished line and wash drawings.

ILLUSTRATED MAIL, *Carmelite House, E.C.*
1d. W. (Saturday).—Photographs, notes, news, and a serial story, no long articles, and no short stories. No short article stands a chance of acceptance unless it is well illustrated by photos.

ILLUSTRATED SPORTING AND DRAMATIC NEWS, *172, Strand, W.C.*
6d. W. (Friday).—Any stories, articles relating to sport, and the drama are gladly considered, but these must be bright and up-to-date. No *preliminary letter* is required.
Illustrations: Photos and wash drawings gladly received, but must be addressed Art Editor.

ILLUSTRATED TEMPERANCE MONTHLY AND HAND AND HEART MAGAZINE, *4, Sanctuary, Westminster, S.W.*
1d. M. (25th).—Short tales of general interest for family reading are considered. A *preliminary letter* is optional.
Illustrations: Line illustrations preferred.

IMPERIAL AND ASIATIC QUARTERLY REVIEW, *Oriental Institute, Woking.*
5s.—Well-considered articles on the history, topography, sociology, etc., of the East, about 4,000 to 8,000 words in length

INDEPENDENT REVIEW, E. Jenks, *11, Paternoster Buildings, E.C.*
2s. 6d. M.—Articles on current events, subjects of the day, etc., from 3,000 to 4,000 words. Serial story. A *preliminary letter* essential.

INTERNATIONAL JOURNAL OF ETHICS, Prof. J. S. MacKenzie, *University College Cardiff.*
2s. 6d. Q.—A journal of matters concerning ethics, sociology, and philosophy. Articles on these subjects may be sent on approval. A *preliminary letter* is desirable.

INTERNATIONAL MUSICAL JOURNAL, Dr. Charles Maclean, *54, Great Marlborough Street, W.*
6d. M.—

INTERNATIONAL MUSICAL QUARTERLY, Dr. Charles Maclean, *54, Great Marlborough Street, W.*
5s. Q.—

INVESTOR'S CHRONICLE, G. J. Holmes, *Tower Chambers, London Wall, E.C.*
6d. M.—High-class monthly financial review. Subjects of interest or matters bearing on financial values accepted. Remuneration, 10s. 6d. per page.

INVESTORS' MONTHLY MANUAL, Edward Johnstone, *3, Arundel Street, W.C.*
1s. M.—

IRON AND COAL TRADES REVIEW, J. Stephen Jeans, *165, Strand, W.C.*
6d. W.—The kind of matter published is such as would be interesting to the iron or the coal trades from a trade or technical standpoint. Illustrations accepted should be such as relate in some way to those industries, either ancient or modern. *Payment* per column: 15s. for ordinary matter, and 20s. for special matter.

IRISH MONTHLY, Rev. Matthew Russell, S.J., *50, Upper O'Connell Street, Dublin.*
6d. M. (26th).—While claiming to be a magazine of general literature, the *Irish Monthly* looks specially to the Irish Catholic, and religious public. It does not invite outside contributions.

IRONMONGER, UNIVERSAL ENGINEER, & METAL TRADES' ADVERTISER, A. C. Meyjes, *42, Cannon Street, E.C.*
6d. W.—Technical or commercial articles on subjects relating to the hardware and metal trades. *Payment* by arrangement. The journal is supplied only to persons connected with the trades represented by it.

JABBERWOCK, Brenda Girvin, *11, Henrietta Street, W.C.*
6d. M.—A magazine for children that aims chiefly at being amusing and entertaining. Short and serial stories. The editor is glad to consider contributions.
Illustrations: Cover may vary. Frontispiece, tail pieces, full pages, story and article illustrations in line or wash, of interest to children.

JESTER AND WONDER, *2, Carmelite House, E.C.*
1d. W.—Smart, topical and witty contributions. Original ideas in black and white, comic sketches. All copy must be typewritten. No *preliminary letter* necessary. *Payment* on application.

JEWISH CHRONICLE, Solomon Davis (Publisher and Manager), *2, Finsbury Square, E.C.*
2d. W.—Articles or illustrations referring to Jewish subjects are considered.

JEWISH EXPRESS, *89, Commercial Street, E.*
½d. and 1d. D. and W.—

JEWISH QUARTERLY REVIEW, I. Abrahams; C. G. Montefiore, *St. Martin's Street, W.C.*
3s. 6d. M.—This review contains articles on Old Testament criticism and history, Rabbinic theology, Jewish history and archæology, and current religious questions. Articles average 7,000 words. *Payment:* From 12 to 20 shillings per 1,000 words.
Illustrations: Only facsimiles of documents.

JEWISH WORLD, John Raphael, *90, Chiswell Street, E.C.*
1d. W.—The paper has a large staff of outside contributors, and, therefore, a *preliminary letter* of enquiry should be sent. Contributions are generally written to order.
Illustrations: Anything of Jewish interest, either topical or of notable persons.

JOURNAL OF EDUCATION, *3, Broadway, Ludgate Hill, E.C.*
6d. M. (1st).—Occasional notes, reports, articles from about 1,000 to 4,000 words, of general interest to those engaged in educational work.

JOURNAL OF HORTICULTURE, R. Milligan Hogg, *12, Mitre Court, Fleet Street, E.C.*
2d. W. (Thursday).—

JOURNAL OF MENTAL SCIENCE, Henry Rayner, M.D., and others, *7, Great Marlborough Street, W.*
5s. Q.—Original articles of a technical kind, proceedings, reports, etc.

JUDY, Edward De Marney, *57 and 58, Chancery Lane, W.C.*
2d. W.—Monday.—This paper contains short stories and jokes. Sporting, technical, and other skits. *Remarks:* All intending contributors must be subscribers.
Illustrations: Humorous line drawings, and half-tone drawings accepted. The Editor is always pleased to entertain work from young black and white artists, and devotes Thursday to seeing all callers on such matters.

JURIDICAL REVIEW, H. P. Macmillan, *18 and 20, St. Giles Street, Edinburgh.*
3s. 6d. Q.—

JUSTICE OF THE PEACE, S. G. Lushington, M.A., B.C.L.; W. Mackenzie, M.A., C. E. Allan, LL.B., M.A., *7 and 8, Fetter Lane, E.C.*
6d. W.—

JUVENILE TEMPLAR, *168, Edmund Street, Birmingham.*
½d. M. (1st).—An illustrated temperance magazine for the young. Very short stories and articles of interest to young people may be sent on approval.

KING AND HIS ARMY AND NAVY, Comm. C. N. Robinson, R.N., *5, Tavistock Street, Covent Garden, W.C.*
6d. W. (Thursday).—This journal contains articles and short stories. No *preliminary letter* is required, but a letter should be sent with con-

tributions. *Remarks: The King* is especially concerned with London or urban matters, but particularly those relating to Royalty.
Illustrations: Cover design and frontispieces for special numbers. Tail pieces, full page, story and article illustrations in line, wash, or photos.

KNOWLEDGE AND SCIENTIFIC NEWS, Major Baden-Powell and E. S. Grew, *27, Chancery Lane, W.C.*
6d. M. (1st).—A journal containing articles on scientific subjects. Original articles of practical value, especially those dealing with novel scientific observations, are welcome. No *preliminary letter* is necessary. Short articles preferred, but occasionally good articles of 6,000 or 8,000 words taken. Rates vary.
Illustrations: Line or photos illustrating articles only; diagrams. Good photographs and illustrations of scientific value.

LABOUR LEADER, J. Bruce Glasier, *10, Red Lion Court, Fleet Street, E.C.*
1d. W.

LABOUR NEWS, G. Shepherd, *10, Farringdon Avenue, E.C.*
1. W.—

LA CHRONIQUE, A. P. Huguenet, *29, Bessborough Street, S.W.*
W. (Saturday).—The only French paper published in London.

LADIES' FIELD, Lady Colin Campbell and P. C Parr, *Southampton Street, Strand, W.C.*
6d. W. (Wednesday).—A journal devoted to the interests of educated women, especially such as are interested in outdoor life. But the paper deals also with music, art, passion, society, and the drama. Articles on sporting subjects with illustrations are required, also some short stories and occasional serials. The length of articles should be from 1,000 to 1,500 words. A *preliminary letter* is desired. *Remarks:* Various competitions are offered.
Illustrations: Cover designs and frontispieces for special numbers. Story and article illustrations, tail pieces, in line, wash, or photos; also fashions.

LADY, Rita Shell, *39 and 40, Bedford Street, Strand, W.C.*
3d. W. (Thursday).—A journal devoted to subjects of interest to ladies. Articles should not exceed 1,000 words. A *preliminary letter* is preferred, but all contributions from outside contributors are carefully considered, and when of special interest are frequently accepted. *Payment* by arrangement.
Illustrations: Fashion sketches and story and article illustrations in line, wash, or photos.

LADY OF FASHION, H. Reichardt, *Granville House, Arundel Street, W.C*
2d. W. (Tuesday).—A well-illustrated weekly, containing stories, articles of interest to women, fashions, news, etc. Short articles should be about 1,200 words, and stories about 1,500. All contributions must be up-to-date and brightly written. The serial stories are by well-known writers. *Payment:* Usually one guinea per column.

LADY'S COMPANION, R. S. Cartwright, *8, Johnson's Court, Fleet Street, E.C.*
1d. W. (Monday).—This paper contains stories, articles and illustrations of interest to women. Articles of practical value, on household matters, are particularly acceptable. A *preliminary letter* is not necessary.
Illustrations: No sketches taken.

LADY'S OWN NOVELETTE, *158, Fleet Street, E.C.*
1d. W. (Wednesday).—Each number contains two long complete novelettes of about 18,000 words. Love stories of a suitable length may be sent in, and the matter should be of interest to ladies. A synopsis of the story should be submitted first.

LADY'S PICTORIAL, *172, Strand, W.C.*
6d. W. (Thursday).—An illustrated journal for women. Contributors may send in stories from 3,000 to 5,000 words, and social articles of 1,000 words. *Remarks:* Copy and photographs for current numbers received up to 10 a.m., on Monday.
Illustrations: Cover designs and frontispieces for special numbers. Tail pieces, story and article illustrations in line, wash or photos; also fashions and needlework designs.

LADY'S REALM, E. Keble Chatterton, *34, Paternoster Row, E.C.*
6d. M. (28th).—An illustrated magazine specially appealing to ladies. The Editor is glad to consider short stories from 1,500 to 3,000 words; also some poems and articles of about 2,000 words are accepted. The latter should be on subjects of particular interest to ladies, and are preferred when suitable for illustration. A *preliminary letter* is not necessary. *Remarks:* Outside contributions are not invited, but will always receive due attention.
Illustrations: Cover varies, frantispiece, full pages, tail pieces, story and article illustrations in line, wash or photos; also fashions.

LADY'S WEEKLY, F. A. W. Oliver, *5, Arundel Street, W.C.*
1d. W.—

LADY'S WORLD, Helen Taylor, *125, Fleet Street, E.C.*
3d. M. (10th).—An illustrated magazine for ladies, containing serial stories from 40,000 to 42,000 words, short stories from 1,000 to 4,000 words, and articles on topical interest, fashions, etc. Poems are also sometimes accepted. A *preliminary letter* is advisable, and outside contributions are not invited.
Illustrations: Cover varies, frontispiece, tail pieces, story and article illustrations in line, wash or photos; also fashions and needlework.

LANCET, Thomas H. Wakley, F.R.C.S., and Thomas Wakley, L.R.C.P., *423, Strand, W.C.*
7d. W. (Saturday).—Very few articles are accepted from outside contributors. Anything sent in must be written by a specialist, and be of particular value.

LAW JOURNAL, Lewis Edmunds, K.C., *37 and 39, Essex Street, W.C.*
6d. W. (Saturday).—

LAW MAGAZINE AND REVIEW, *116, Chancery Lane, W.C.*
5s. Q.—Publishes articles on all matters of interest connected with the legal profession. Length of articles preferred, not less than 10 or more than 15 pp. (page, 350 words).

LAW TIMES, Basil Crump, *Breams Buildings, Chancery Lane, E.C.*
1s. with weekly part of *Law Times Reports;* 9d. without Reports. W. (Saturday).—Articles of about 1,000 words are sometimes accepted if of technical and general legal interest. Also articles for the literary column, but must be of interest to lawyers. No *preliminary letter* is required. *Remarks:* Vacancies for barristers from time to time on reporting staff.

LAYMAN, *27 and 28, Fetter Lane, E.C.*
3d. W. (Friday).—

LESLIE'S WEEKLY, *225, Fourth Avenue, New York.*
1d. W. (Tuesday).—This journal contains illustrations and articles of general interest. Contributions are only accepted by arrangement. *Remarks:* No hard and fast rule.
Illustrations: Mainly good photos.

LIBERAL MAGAZINE, Charles Geake, *42, Parliament Street, S.W.*
6d. M.—

LIBERTY REVIEW, *17, Johnson's Court, Fleet Street, E.C.*
6d. M. (15th).—

LICENSED VICTUALLERS GAZETTE, *81, Farringdon Street, E.C.*
2d. W. (Friday).—

LIFE AND WORK, Rev. Dr. Fisher, *42, Hanover Street, Edinburgh.*
1d. M. (1st).—This journal contains articles on mission work, religion, biography and history, also short and serial tales and occasional poems. MSS. should take the form of short stories of about 1,000 to 2,200 words, or serials or articles on suitable subjects, varying from 1,000 to 2,000 words in length. No *preliminary letter* is required. *Payment:* Liberal, but varies according to value of contribution. *Remarks:* Being a Church magazine articles of a secular tone are not desired.
Illustrations: Stories and articles are illustrated in line, wash or photos.

LIGHT, E. Dawson Rogers, *110, St. Martin's Lane, W.C.*
2. W.—*Light* is a weekly journal of psychical, occult, and mystical research.

LITERARY WORLD, F. H. Fisher, *13, Fleet Street, E.C.*
3d. M.—As the name implies, this journal is devoted almost entirely to literary subjects. Outside work is only occasionally accepted, and in such cases it must be of a high-class character, and of special interest. A *preliminary letter is necessary.*

LITTLE FOLKS, S. H. Hamer, *La Belle Sauvage, E.C.*
6d. M. (25th).—A magazine for young people containing short and serial tales, poems, and some descriptive articles. Short stories should be about 1,800 words in length, and should be bright and healthy in tone. Poems are generally preferred when humorous. A *preliminary letter* is not necessary.
Illustrations: Covers varies, frontispiece coloured, full pages, tail pieces, story and article illustration in line, wash, or photos.

LIVE-STOCK, *9, New Bridge Street, E.C.*
4d. W. (Friday).—Devoted to the interests of stockbreeders, studs, herds, etc., and written for owners and exhibitors. Sometimes contains serial articles, but chiefly reports.

LLOYD'S WEEKLY NEWS, Thomas Catling, *12, Salisbury Square, E.C.*
1d. W. (Saturday and Sunday).—This paper contains the news of the week and articles on matters of general interest. Contributions should take the form of short or serial tales, articles of an original character, and literary subjects. A *preliminary letter* should precede any serial. *Payment:* Usually 1½ guineas per column.

LONDON MAGAZINE, C. P. Sisley, *Carmelite House, E.C.*
4½d. M. (15th).—Very short stories and articles from 1,000 words are frequently accepted. Ideas for articles which can be illustrated are also gladly received. Other contributions, such as short stories, bright and interesting, under 3,000 words, and articles under 4,000, are considered. MSS. should be folded, not rolled, and should be typewritten.
Illustrations: Cover varies, illustrations line, wash, or photos.

LONDON OPINION AND TO-DAY, A. Morton Mandeville, *36, Southampton Street, Strand, W.C.*
2d. W. (Wednesday).—The Editor will be pleased to consider MSS., particularly those of a topical sort. Satirical verse and parodies turning on events of the hour will receive special attention. Short, crisp stories, of about 2,000 words, dialogues from 600 to 1,200 words. Also humorous articles not exceeding 1,200 words, and short original anecdotes. *Payment:* A guinea per page (about 1,200 words). *Remarks:* Nothing heavy, morbid, or neurotic will be considered. Serious articles need only be sent if short, topical, and of general interest.
Illustrations: Original pen-and-ink line drawings of a humorous or topical nature are invited. MSS. and drawings should be accompanied by stamped addressed envelopes for return in case of unsuitability.

LONDON QUARTERLY REVEW, Rev. John Telford, B.A., *2, Castle Street, City Road, E.C.*
2s. 6d.—This Review deals with theological and general subjects from a Methodist standpoint. Articles written in such a manner as to be suitable for the paper are considered. A *preliminary letter* is advisable.

MACHINERY MARKET, Arthur Wadham, *146a, Queen Victoria Street, E.C.*
1d. W.—

MACMILLAN'S MAGAZINE, Mowbray Morris, *St. Martin's Street, W.C.*
6d. M. (25th).—A high-class magazine containing articles and essays on history, travel, or topics of general and current interest, from 3,000 to 6,000 words; also a serial. *Remarks:* The Editor will not be responsible for return of contributions in verse, and contributors are not entitled to demand the publication of their signature.

MADAME, Ramsay Colles, *7, Essex Street, Strand, W.C.*
3d.W. (Wednesday).—An illustrated magazine, devoted to the interests of women containing articles, stories, and social news. Average length of articles and stories, 2,000 words. Anything of special interest to women may be sent for consideration. No *preliminary letter* is desired. *Payment:* £1 1s. per thousand.
Illustrations: Cover designs and frontispiece for special numbers. Story and article illustrations in line, wash or photos; also fashions. Preference given to wash.

MAGAZINE OF COMMERCE, Frank F. Bridgewater, *155 and 156, Cheapside, E.C.*
1s. M. (25th).—Articles on commercial subjects of practical interests and which can be illustrated are acceptable. A *preliminary letter* is not essential, but desirable.

MAGAZINE OF FINE ARTS, *Southampton Street, Strand, W.C.*
1s. M.—A high-class illustrated magazine, devoted exclusively to the fine and decorative arts of past times. Articles should be reliable and instructive, and the writers must have made a special study of the subjects which they treat.

MAN, The Secretary of the Anthropological Institute, *3, Hanover Square, W.*
1s. M.—The paper is entirely scientific, dealing in anthropology and ethnology. Consequently no payment is made for articles, as authors are glad of an opportunity of publishing their work.
Illustrations: Either in colours, half-tone, or line, and are only used in connection with articles.

M.A.P., T. P. O'Connor, *18, Henrietta Street, W.C.*
1d. W. (Thursday).—Short stories either 1,500 or 2,200 words with a good plot and a pleasant termination are considered. Also paragraphs or

anecdotes concerning living and notable people. These must be thoroughly up-to-date. *Payment:* £1 per 1,000 words for outside work. £2 to £4 per 1,000 words for commissioned work.

MARK LANE EXPRESS, *1, Essex Street, W.C.*
3d. W. (Monday).—

MARVEL LIBRARY, Hamilton Edwards, *2, Carmelite House, E.C.*
1d. W.—Complete stories of 15,000 or 22,000 words. Good healthy adventure; sea; school; historical or foreign lands. Plenty of incident and no elaborate verbiage. All copy must be type-written.

MAYFLOWER NOVELETTE, *158, Fleet Street, E.C.*
½d. W. (Wednesday).—Contains complete novelettes, of 20,000 words. MSS. sent in should have a strong love interest, and should be suitable for illustration. A *preliminary letter* should be sent, and a short synopsis of the story may be submitted with it.

MEDICAL REVIEW, *66, Finsbury Pavement.*
1s. 6d. M.—

MEDICAL TIMES, Dr. George Brown, *11, Adam Street, W.C.*
2d. W.—

MERCANTILE GUARDIAN, W. Lindley Jones, *21, St. Helen's Place, E.C.*
25s. per annum. M.—
Contains news affecting export trade and trade openings all over the world. The Editor is always ready to consider brief articles and paragraphs on subjects interesting to those engaged in the trade between the United Kingdom, the Colonies, and foreign countries, but they must be pithily worded. A twenty-line paragraph preferred to a column article. *Payment* depends on value of copy.

METHOD, R. Denman Morris, *231, Strand, W.C.*
6d. M.—

METHODIST NEW CONNEXION MAGAZINE, *23, Farringdon Avenue, E.C.*
3d. M. (1st).—

METHODIST RECORDER, Rev. Nehemiah Curnock, *161, Fleet Street, E.C.*
1d. W. (Thursday).—This journal is devoted to the interests of Methodists, and contains stories and articles which have some bearing on the doings of Methodists. Stories should be from 1,500 to 3,000 words, and articles from 2,000 to 4,000 words. A *preliminary letter* is not necessary. Ordinary *payment*, 10s. 6d. per column.
Illustrations: From good silver-prints.

METHODIST TIMES, Percy W. Bunting, *125, Fleet Street, E.C.*
1d. W. (Thursday).—This journal contains some short stories and articles on religious subjects. The articles should be about 1,000 words long, and the occasional story should not exceed 3,000 words. A *preliminary letter* is advisable.

MILITARY MAIL, A. E. Druett, *2, Amen Corner, E.C.*
1d. W. (Friday).—The articles accepted are only such as deal with military subjects. They should be from 1,400 to 1,500 words in length. There are also short stories. A *preliminary letter* is not necessary.

MIND, Prof. G. F. Stout *(The University, St. Andrew's), 14, Henrietta Street, W.C.*
4s. Q.—A quarterly review of psychology and philosophy intended for those who have studied and thought on these subjects. Articles from about 5,000 words.

MINIATURE NOVELS, *6, West Harding Street, E.C.*
1d. W. (Friday).—Contains two long complete stories, of 30,000 words and upwards.

MINING JOURNAL, Baliol Scott, *46, Queen Victoria Street, E.C.*
6d. W.—The matter desired is anything original, describing mining or metallurgy in any part of the world, and the illustrations are photos or drawings which *really* illustrate the text. *Payment:* Average rate, 21s. per column.

MIRROR NOVELS, *158, Fleet Street, E.C.*
1d. W.—Contains a long complete story of about 18,000 words, and two serials. Contributors should state what remuneration they desire.

MIRROR OF LIFE, *10, Bread Street Hill, Queen Victoria Street, E.C.*
2d. W.—

MISSIONARY REVIEW, A. T. Pierson, *44, Fleet Street, E.C.*
1s. M.—

MODERN LANGUAGE REVIEW, Prof. John G. Robertson, *5, Lyon Road, Harrow.*
2s. 6d. net. Q.—Contains papers of a scholarly or specialist character, embodying the results of research or critical investigation; also short notes of value from contributors.

MODERN SOCIETY, *18, Kirby Street, Hatton Garden, E.C.*
1d. W. (Saturday).—A paper devoted chiefly to the sayings and doings of society. It contains personal paragraphs concerning society people, anecdotes of distinguished men and women, social articles, criticisms of Music and the Drama, and a short story.

MONEY MARKET REVIEW, *21-25, Dean Street, E.C.*
6d. W.—(Saturday).—

MONIST, *43, Gerrard Street, W.*
2s. 6d. Q.—

MONTH, *31, Farm Street, W.C.*
1s. (1st).—This journal is devoted to the interests of the Catholic literary world. Articles on such subjects as suit the general tone of the publication, usually theological or literary, may be sent in. A *preliminary letter* is required.

MONTHLY MAGAZINE OF FICTION, *23, Henrietta Street, W.C.*
3d. M.—This takes the form of a complete novel of about 50,000 words. MSS. answering to this description may be sent on approval. *Payment* on acceptance.

MONTHLY REVIEW, Charles Hanbury Williams, *50, Albemarle Street, W.*
2s. 6d. M. (28th).—Length of articles preferred, 3,000 to 5,000 words. Kind of matter desired, political articles, articles of general interest, occasional verse. Short stories sometimes accepted.

MORNING ADVERTISER, G. W. Talbot, *127, Fleet Street, E.C.*
1d. D.—Articles of general interest, suitable for the paper, and news paragraphs are considered. *Payment:* From one guinea per 1,000 words.

MORNING LEADER, *Stonecutter Street, E.C.*
½d. D.—Special articles of current interest, cartoons, photos, and other matter, may be sent for consideration.

MORNING POST, Fabian Ware, *346, Strand, W.C.*
1d. D.—Special news paragraphs and occasional articles on current topics, which must be written by people who have special knowledge of their subject, are considered. *Payment:* From one guinea per 1,000 words upwards.

MOTHER'S TREASURY, *149, Strand, W.C.*
1d. M. (20th).—Articles and stories for family reading, advice to mothers, etc., may be sent for consideration. A *preliminary letter* is optional, but not necessary.

MOTOR CAR JOURNAL, C. Cordingley, *39, Shoe Lane, E.C.*
1d. W.—

MOTOR CAR MAGAZINE, Hon. John Scott Montagu, M.P., *17, Shaftesbury Avenue, W.*
6d. M.—Short articles of motoring and travel interest, with photographs or drawings, traffic problems, etc., may be sent for consideration. *Payment:* Average rate for short stories, one guinea per thousand words.

MOTOR NEWS, R. J. Mecredy, *34, Lower Abbey Street, Dublin.*
1d. W. (Saturday).—Paragraphs, news items, interesting incidents, useful hints and tips, roadside experiences, humorous paragraphs, are chiefly required. All articles must deal with automobile matters. A *preliminary letter* is not necessary.
Illustrations: Photos only.

MOTORING ILLUSTRATED, *11, Arundel Street, Strand, W.C.*
1d. W. (Thursday).—A journal devoted to the interests of motorists; fully illustrated and brightly written. Technical articles on motors accepted and well paid for if suitable.
Illustrations: Photos and humorous line drawings.

MOTORIST AND TRAVELLER, *12, Henrietta Street, Covent Garden, W.C.*
3d. W. (Wednesday).—A high-class weekly illustrated paper for motorists and travellers. Articles from 1,000 to 1,500 words; these should be accompanied by photos. *Remarks:* Best subjects for contributions: Notes with snapshots of incidents of motor travel, of accidents, of the condition of roads, of police traps, of interesting inventions; articles on clothing; special articles on travel and on subjects of interest to travellers.
Illustrations: Photos.

MUNICIPAL JOURNAL, Robert Donald, *12, Salisbury Square, E.C.*
2d. W.—The national organ of municipal government.

MUSICAL NEWS, J. Percy Baker, *130, Fleet Street, E.C.*
1d. W.—(Friday).—This magazine is devoted entirely to the interest of musicians. Contributors may send news, short articles, etc., concerning the profession. A *preliminary letter* is desirable.

MUSICAL STANDARD, *83, Charing Cross Road, W.C.*
2d. W. (Friday).—

MUSICAL TIMES, F. G. Edwards, *1, Berners Street, W.*
4d. M.—

MUSICAL WORLD, *Carr Street, Manchester, and 115, Fleet Street, London, E.C.*
3d. M. (15th).—An illustrated journal of articles, notes, criticisms, etc., on music. Articles should not exceed 2,000 words, and should be brightly written.

MY POCKET NOVELS, *6, West Harding Street, Fetter Lane, E.C.*
1d. W. (Wednesday).—Two long complete stories are contained in each number. Novels with a strong love interest and plenty of incident may be sent in. A *preliminary letter* is advisable.

MY QUEEN LIBRARY, *1, 2 and 3, Crown Court, Chancery Lane, E.C.*
1d. W. (Tuesday).—Each number contains one complete novel, about 30,000 words. Stories should be full of incident and move briskly, they should have strong romance running through them. A *preliminary letter* is preferred, and a synopsis of the story may be sent with it.
Illustrations: In line.

MYRA'S JOURNAL, Juliette Heale, *10 and 11, Fetter Lane, E.C.*
3d. M. (15th previous month).—Very little outside work is taken, but good prices are offered for high-class fashion sketches, and ideas of general utility (especially on dress and hygiene). Short interesting novelettes are required.
Illustrations: Fashion sketches occasionally.

NATURALIST, T. Sheppard, F.G.S.; T. W. Woodhead, F.L.S., *5, Farringdon Avenue, E.C.*
6d. M.—This journal contains articles dealing with the natural history or archæology of the Northern Counties. It is illustrated.

NATURE, *St. Martin's Street, W.C.*
6d. W. (Thursday).—This paper is devoted entirely to scientific matters. Articles on every scientific subject are considered.

NATIONAL REVIEW, L. J. Maxey, *37, Bedford Street, Strand, W.C.*
2s. 6d. M. (30th).—General articles of all kinds, of about 10 pages in length are gladly considered; the page contains about 420 words. These must be original, hackneyed work is not appreciated. A *preliminary letter* is required. *Payment* varies from 10s. to £5 per page.

NATURE NOTES, Professor Boulger, *83, Great Titchfield Street, W.*
2d. M. (1st).—Natural history notes, articles and illustrations, are considered, but must be sent in gratuitously, for no *payment* is made. *Remarks:* The magazine is primarily the organ of the Selborne Society.

NATURALISTS' QUARTERLY REVIEW, W. J. Davis, *31 and 33, Hythe Street, Dartford.*
2s. 6d. per annum (re-issue).—The Editor will be glad to receive contributions, notes, records, etc.
Illustrations: Photographs.

NAUTICAL MAGAZINE, R. Irvine Brown, *52 to 56, Darnley Street, Pollokshields, E., Glasgow.*
1s. M. (1st).—Articles. relating to nautical profession only, from 2,600 to 3,500 words, may be sent on approval. *Payment:* 5s. per page.

NEW AGE, Harold Rylett, *1, Took's Court, E.C.*
1d. W. (Thursday).—This journal contains articles on political, social and religious topics. These should be short and concise, usual length rom 1,000 to 2,000 words. A *preliminary letter* is not necessary.

NEW IRELAND REVIEW, T. A. Finlay, *94-96, Mid Abbey Street, Dublin.*
6d. M.—Contains literary and scientific articles.

NEWS OF THE WORLD, Emsley Carr, *30, Bouverie Street, E.C.*
1d. Tri-weekly.—News of the week in the form of short paragraphs will be considered.
Illustrations: News illustrations, photos, line or wash sketches.

NEWSAGENT AND BOOKSELLER'S REVIEW, G. F. Goulder, *Exeter House, Exeter Street, Strand, W.C.*
1d. W.—

NINETEENTH CENTURY AND AFTER, Sir James Knowles, *5, New Street Square, Fetter Lane, E.C.*

2s. 6d. M. (30th).—This journal contains original articles on topics of current interest, usually only from well-known authors; length, 5,000 to 8,000 words. A *preliminary letter* is preferred.

NORTHERN NOTES AND QUERIES, *61, Quayside, Newcastle.*

1s. 6d. Q.—A quarterly magazine, devoted to the antiquities of Northumberland, Cumberland, Westmorland, and Durham. Original articles of permanent value relating to history, genealogy, heraldry, and archæology, in all its branches, may be sent for consideration.

NOTES AND QUERIES, Joseph Knight, *11, Bream's Buildings, E.C.*

4d. W.—

NOVEL MAGAZINE, *18, Henrietta Street, W.C.*

4d. M. On the 1st of the month.—This magazine contains stories only, of all lengths. MSS. always considered expeditiously. *Payment:* Usually a matter of arrangement, and is on liberal terms, £1 per 1,000 words and upwards. No illustrations.

NOVELIST, *36, Essex Street, Strand, W.C.*

1d. M. (15th).—Full length novels with plenty of dramatic interest may be sent in for consideration.

NUGGETS, *Red Lion Court, E.C.*

1d. W. (Thursday).—A humorous illustrated paper, with long and short stories. MSS. should be of a light and amusing character. A *preliminary letter* is required.

Illustrations: Humorous drawings and story illustrations.

NURSING TIMES, *St. Martin's Street, W.C.*

1d. W.—Edited and written by nursing experts. Articles on practical nursing wanted, and the Editor is also open to receive stories having some nursing interest. *Payment* at full usual rate.

OBSERVATORY, H. P. Hollis; T. Lewis, *Red Lion Court, Fleet Street, E.C.*

1s. M.—Prepared unofficially by members of the staff of the Royal Observatory, Greenwich. It contains articles and correspondence on astronomical subjects, and astronomical news. Contributions are *not* paid for, nor illustrations.

OBSERVER, Robert Bell, *125, Strand, W.C.*

2d. W. (Sunday).—Occasional articles of special merit are accepted from outsiders.

ONLOOKER, Mrs. Harcourt Williamson, *16, Bedford Street, Strand, W.C.*

3d. W. (Tuesday).—A society newspaper, containing sketches, stories, and personal news paragraphs. All contributions should be written in a bright and chatty manner. Short sketches and social news are most acceptable. No *preliminary letter* is required. *Remarks:* Brevity is desirable.

OPTICIAN AND PHOTOGRAPHIC TRADES REVIEW, C. Hyatt-Woolf, *123-125, Fleet Street, E.C.*

2d. W.—The review contains articles or paragraphs of general optical and photographic nature, combined with trade character.

OUR BOYS AND GIRLS, *2, Ludgate Circus Buildings, E.C.*

½d. M. (25th).—An illustrated magazine for children. No outside work need be sent in. Copy is supplied by the staff.

OUR DARLINGS, *48, Paternoster Row, E.C.*
3d. M.—Contains illustrations, articles and stories suitable for children.
A *preliminary letter* is generally preferred.
Illustrations: Cover and frontispiece in colour. Wash, line or photos illustrating stories, articles, or events of interest to children; full pages and head and tail pieces.

OUR HOME, Louise E. Patterson, *6, Essex Street, Strand, W.C.*
1d. W. (Friday).—An illustrated magazine for the family. Contributions should take the form of short or serial stories, articles on domestic and general subjects. Length from 1,800 to 2.500. A *preliminary letter* is optional. *Payment:* Five shillings per column, but special rates for many articles and stories.
Illustrations: Regular staff of artists, but occasional sketches accepted from outsiders. Fashions, fancy work, headings, and frames for portraits only.

OUR HOSPITALS AND CHARITIES, *St. Martin's Street, W.C.*
3d. net. M.—

OUR LITTLE DOTS, *4, Bouverie Street, E.C.*
1d. M. (25th).—An illustrated magazine for very young children. The literary matter is mainly dependent on the illustrations.
Illustrations: For very young children; line, wash or photos.

OUR OWN MAGAZINE, *13a, Warwick Lane, E.C.*
1d. M. (20th).—Contributions should be in the form of true stories illustrating Scripture. No *preliminary letter* is required.
Illustrations: Line, wash, or photos of religious interest.

OUTLOOK, J. L. Garvin, *167, Strand, W.C.*
6d. W. (Saturday).—A journal dealing with topics of current interest. Contributors should study the paper before sending in MSS. *Remarks:* The Editor will take all reasonable care of MSS., but cannot be held responsible for unsolicited contributions. A stamped addressed envelope should always be enclosed for return.

OVERLAND MAIL, *65, Cornhill, E.C.*
6d. W.—

OWL, John H. Summers, *28, Upper Priory, Birmingham.*
1d. W. (Friday).—

PAGE'S WEEKLY, Davidge Page, *Clun House, Surrey Street, W.C.*

PALL MALL GAZETTE, Sir Douglas Straight, *Newton Street, Holborn, W.C.*
1d. D.—News paragraphs, and articles of special interest on topical events, are accepted from outsiders. *Payment:* Varies from one guinea per 1,000 words upwards.

PALL MALL MAGAZINE, Charles Morley, *Newton Street, Holborn, W.C.*
6d. M. (18th).—This magazine contains high-class articles and stories. These should be about 4,000 words in length. They should be well written, and of general interest. No *preliminary letter* is required.
Illustrations: Cover varies. Frontispiece, tail pieces, story, and article illustration in line, wash or photos; also fashions.

PAPER TRADE REVIEW, F. Gillis, *58, Shoe Lane, E.C.*
6d. W.—

PEARSON'S WEEKLY, Peter Keary, *Henrietta Street, W.C.*
1d. W. (Saturday).—Stories about 3,000 words, articles, paragraphs, jokes, and new ideas are gladly considered. A *preliminary letter* is not required. *Payment:* One to three guineas per column. *Remarks:* The writer of every suitable article is sent a form stating the payment offered for his contribution.

PEARSON'S MAGAZINE, P. W. Everett, *Henrietta Street, Covent Garden, W.C.*
6d. M.—A magazine of general interest, containing bright articles and short stories. The short stories should not exceed 6,000 words. New and original articles, suitable for illustration, are gladly considered. A *preliminary letter* is not necessary.
Illustrations: Cover varies. Frontispiece, tail pieces, story and article illustration in line, wash or photos.

PELICAN, Frank M. Boyd, *10 and 11, Fetter Lane, E.C.*
1d. W. (Wednesday).—A paper containing social and general news, articles, and some stories. A *preliminary letter* is usually advisable.

PENNY ILLUSTRATED PAPER, *198, Strand, W.C.*
1d. W. (Friday).—A popular illustrated paper, dealing with news of the day. Sketches and articles are required. No *preliminary letter* is desired.
Illustrations: Frontispiece, tail pieces, story and article illustrations in line, wash, or photos.

PENNY MAGAZINE, *La Belle Sauvage, E.C.*
1d. W. (Tuesday).—An illustrated magazine, containing articles of general interest; these should be on popular lines, and may be instructive, but not scientific or technical. They should run from 500 to 2,000 words in length, and should be suitable for illustration. Short stories of about 2,000 words are also considered. No *preliminary letter* is required. *Payment* by arrangement.
Illustrations: Cover varies. Frontispiece occasionally. Story and article illustrations line, wash or photos.

PEOPLE, Joseph Hatton, *Milford Lane, Strand, W.C.*
1d. W. (Sunday).—This is a paper for the people, containing news paragraphs and short articles on topical events. MSS. are not returned unless stamped envelopes are enclosed for that purpose; copies had better be kept.

PEOPLE'S FRIEND, *Bank Street, Dundee.*
1d. W. (Monday).—A popular paper, containing articles on topical and domestic matters, also short stories and humorous sketches. The stories should be from 3,000 to 4,000 words, articles about 1,500 words, and humorous papers from 1,500 to 2,500 words. No *preliminary letter* is required. *Remarks:* Frequent prize competitions.

PHARMACEUTICAL JOURNAL, John Humphrey, *72, Great Russell Street, W.C.*
6d. W.—Concise articles of 1,000 words or more on scientific and technical subjects, having some connection with pharmacy, may be sent for consideration.
Illustrations: Line drawings preferred to photographs, except in special circumstances.

PHILANTHROPIST, Forster Boulton, *30, Furnival Street.*
6d. M.—The representative organ of all voluntarily supported charities. A special feature is made of descriptive and illustrated articles on charities.

PHILOSOPHICAL REVIEW, J. G. Schurman; J. E. Creighton; James Seth, *St. Martin's Street W.C.*
3s. net. Bi-monthly.—

PHOTOGRAPHIC CHAT, C. Hyatt-Woolf, *123-25, Fleet Street, E.C.*
1d. M.—Any popular articles for amateur photographers (not illustrated), about 300 words in length, may be sent on approval.

PHOTOGRAPHIC MONTHLY (PHOTOGRAM), *6, Farringdon Avenue, E.C.*
3d. M. (25th).—Short practical articles on photography for amateurs and professionals are required. A *preliminary letter* is preferred. *Payment:* £1 per 1,000 words.

PHOTOGRAPHIC NEWS, P. R. Salmon, *9, Cecil Court, Charing Cross Road, W.C.*
1d. W. (Friday).—A journal devoted entirely to photography, especially to the interests of the amateur. Articles on technical and pictorial photography are considered. A *preliminary letter* is advisable but not necessary.

PHOTOGRAPHY, R. Child Bayley, *20, Tudor Street, E.C.*
1d. W. (Monday).—Outside contributions are very seldom accepted, only in the case of specialists, and then the articles are usually commissioned.

PHYSICAL REVIEW, Edward L. Nichols; Ernest Merritt; Frederick Bedell, *St. Martin's Street, W.C.*
3s. net.—

PICK-ME-UP, Arnold Golsworthy, *16, King William Street, E.C.*
1d. W. (Tuesday).—An illustrated comic and satirical paper, containing short racy articles and sketches. These should be about 1,000 words. A *preliminary letter* is not necessary. *Payment* from £1 1s.
Illustrations: Always open to consider line or wash drawings of *unconventional* kind.

PICTORIAL COMEDY, *Red Lion Court, Fleet Street, E.C.*
6d. M. (Third Thursday).—This contains short stories and dialogues. Contributions should be of a humorous character. A *preliminary letter* is optional.
Illustrations: Humorous line and wash drawings.

PICTORIAL MAGAZINE, Charles P. Sisley, *Carmelite House, E.C.*
1d. W. (Friday).—A popular illustrated magazine, containing articles on general subjects, short stories, some serials, etc. Romantic and dramatic stories from 3,000 to 5,000 words are gladly considered. A *preliminary letter* is not required. *Payment:* One guinea per 1,000 words.
Illustrations: Line or wash drawings to illustrate stories and articles. Frontispieces and cover designs.

PIGEONS AND POULTRY, J. E. Watmough, *High Street, Idle, Bradford, Yorks.*
1d. W.—

PLAY PICTORIAL, Fred Dangerfield, *6, Adam Street, Strand, W.C.*
6d. M.—

PLAYTIME, Mrs. Ballin, *5, Agar Street, Strand, W.C.*
1d. M. (1st).—A magazine for children containing stories and pictures. No *preliminary letter* is required.

PLUCK, Hamilton Edwards, *Carmelite Street, E.C.*
1d. W. (Saturday).—A magazine for boys, containing healthy, bright stories, well illustrated. MSS. of complete stories, dealing with adventure, peril, heroism and detective work, are gladly considered. Length should be 18,000 or 25,000 words respectively. A synopsis of story must be submitted before hand. *Payment:* Complete stories from eight to twelve guineas. Sketches, 10s. 6d. to one guinea. *Remarks:* Established by Messrs. Harmsworth, and provides healthy boys' yarns against the pernicious factor of the penny and halfpenny papers.
Illustrations: Line drawings only.

POLITICAL SCIENCE QUARTERLY, *9, St. Martin's Street, Leicester Square, W.C.*
A scientific and political quarterly, containing articles of importance. Only contributions that show special knowledge on matters of political history, public law, and economics will be considered. Usual length from 4,000 to 8,000 words. A *preliminary letter* is advisable. *Payment:* 8s. per page (about 370 words). *Remarks:* Though published in England, this journal is edited at the Columbia University, New York, and letters concerning contributions should be addressed there, to Prof. Wm. A. Dunning.

POULTRY, Fred. J. Broomhead, *12, Mitre Court Chambers, E.C.*
1d. W.—Staff is composed of specialists, so outside contributions are rarely accepted.
Illustrations are always of special subjects.

PRACTICAL ENGINEER, with "INVENTIONS SUPPLEMENT" WEEKLY, *359, Strand, W.C.*
2d. W.—

PRACTICAL PHOTOGRAPHER, Rev. F. C. Lambert, *27, Paternoster Row, E.C.*
1s. M.—

PRACTITIONER, *149, Strand, W.C.*
2s. M.—

PREACHER'S MAGAZINE, Rev. Arthur E. Gregory, D.D., *26, Paternoster Row, E.C.*
4d. M.—This magazine contains Biblical exposition, homiletic outlines, sketches of preachers, etc. Length of articles : 4 to 8 pages. *Payment:* 3s. to. 5s. per page.

PRIMITIVE METHODIST QUARTERLY, H. B. Kendall, B.A., *48-50, Aldersgate Street, E.C.*
2s.—Articles on religious and social questions are considered. A *preliminary letter* is preferred. *Payment:* Only by arrangement with the Editor.

PRINCESS NOVELS, *6, West Harding Street, E.C.*
1d. W. (Monday).—A complete novel is issued every week. Contributors should send in dramatic tales full of incident and with a strong love interest, about 20,000 words, also serial stories about 60,000 words. *Remarks:* All MSS. submitted must lend themselves to illustration, and must be typewritten, also stamps must be enclosed for return of MSS. if desired, in case of unsuitability.

PROGRESS, (Hon.) Godfrey H. Hamilton, *206, Great Portland Street, W.*
M. (1st).—Printed in Braille type for the blind. All editorial work and contributions supplied gratuitously. Contains official news of the B. and F.B.A., short stories and articles (100 to 800 words), chiefly of interest to the blind.

PUBLIC HEALTH, F. J. Allan, *1 Upper Montague Street, Russell Square, W.C.*
 1s. 6d. M.—Is the official journal of the Society of Medical Officers of Health, by whom it is published.

PUBLIC OPINION, *6, Bell's Buildings, Salisbury Square, E.C.*
 2d. W. (Friday).—

PUBLIC WORKS, Gibson Thompson, *24, Bride Lane, E.C.*
 1s. Q.—Articles of about 2,000 to 3,000 words preferred. Strictly technical, and confined to Governmental or Municipal Engineering, with architectural works in England or abroad. *Payment* by arrangement.
 Illustrations: Photographs and (especially) engineering diagrams.

PUBLISHERS' CIRCULAR, R. B. Marston, *134-137, Fetter Lane, E.C.*
 1½d. W.—

PUNCH, Sir F. C. Burnand, *10, Bouverie Street, E.C.*
 3d. W. (Tuesday).—Sketches and short satirical articles are sometimes accepted from outside contributors, but only if they are of special merit. A *preliminary letter* is required. *Payment:* By arrangement and very liberal.

QUARRY, Allan Greenwell, *30 and 31, Furnival Street, E.C.*
 6d. M.—

QUARTERLY REVIEW, G. W. Prothero, *50a, Albemarle Street, W.*
 6s.—This review contains articles on politics, history, literature, philosophy, etc. Essays of outstanding merit on the above-mentioned subjects are considered. They should be type-written. A *preliminary letter* to the Editor is advisable.

QUEEN, Percy S. Cox, *Bream's Buildings, E.C.*
 6d. W. (Saturday).—A high-class illustrated journal for ladies, containing short articles, news paragraphs and fiction. Articles should be about 1,000 words in length. Stories are not often accepted from outside contributors. A *preliminary letter* is desirable. *Payment:* Usually 25s. per column of 1,500 words.
 Illustrations: Cover designs and frontispieces for special numbers, story and article illustrations in line, wash or photos; also fashions, furniture, animals, and needlework designs.

QUIVER, David Williamson, *La Belle Sauvage, E.C.*
 6d. M. (25th).—This contains serial and short stories, and general articles, such as are suitable for a family paper. A *preliminary letter* is required. *Remarks:* All MSS. must be typewritten.
 Illustrations: Cover varies. Frontispiece, tail pieces, story and article illustrations in line, wash or photos.

RAILWAY GAZETTE, W. H. Boardman, *Queen Anne's Chambers, Westminster, S.W.*
 6d. W.—A journal devoted to the interests of railways, docks, canals, harbours and shipping. Articles of practical interest on the carrying trade in any part of the world are gladly considered. A *preliminary letter* is desirable. All communications to be addressed to "The Editor."

RAILWAY MAGAZINE, G. A. Sekon, *30, Fetter Lane, E.C.*
 6d. M. (25th).—An illustrated magazine, dealing with all railway subjects; not fiction. Articles from 2,500 to 5,000 words. No *preliminary letter* is required. *Remarks:* The Editor may be seen all week-days, except Saturday, from 3 to 4 p.m.
 Illustrations: Photos and line drawings only. Cover varies. Frontispiece.

RAPID REVIEW, *Henrietta Street, W.C.*
6d. M. (12th).—A concise summary of the events of the month, political, social, home and foreign—and all the most interesting articles in the reviews and magazines of the month.

RECORD, Rev. A. R. Buckland, *1, Red Lion Court, E.C.*
1d. W. (Friday).—A religious paper, recognised as the organ of the Evangelical Party of the Church. Articles on Church matters, missionary work, and news paragraphs concerning Church work may be sent to the Editor. No *preliminary letter* is required.

RECORD OF TECHNICAL AND SECONDARY EDUCATION, Frederick Oldman, *St. Martin's Street, W.C.*
2s. 6d. Q.—The organ of the National Association for the Promotion of Technical and Secondary Education. Kind of matter published : Articles and material on the organisation and development of education other than elementary.

RED LETTER, David Donald, *109, Fleet Street, E.C.*
1d. W. (Wednesday).—A home magazine. Ready opening for strong serials of love, mystery, pathos, and thrilling incident. Opening instalment and synopsis sufficient for first consideration. Short stories (1,800 to 3,500 words), and popular articles on topical subjects also invited. No *preliminary letter* required, except in the case of serials.

REFEREE, Richard Butler, *Victoria House, Tudor Street, E.C.*
1d. W. (Sunday).—This journal deals with sport and the drama and contains the very latest news. Paragraphs and short articles of a suitable nature may be sent in. *Remarks: The Referee* does not invite outside contributions, but does not refuse them. Matter accepted is paid for according to merit.

REGIMENT, H. Smart, *7-15 Rosebery Avenue, E.C.*
1d. W.—A real Service paper.

RELIQUARY, J. Romilly Allen, *4, Snow Hill, E.C.*
2s. 6d. Q.—Contains articles on early art and archæology. These should be about 3,000 words in length, with six or more illustrations. A *preliminary letter is required.*

REVIEW, *677-678, Mansion House Chambers, E.C.*
6d. W. (Friday).—Articles on fire, life, and accident business. No restriction as to length of articles. Rate of *payment:* 15s. per column.

REVIEW OF REVIEWS, W. T. Stead, *Mowbray House, Norfolk Street, W.C.*
6d. M. (10th).—Very little work is accepted from outside contributors, and anything submitted should be of a special interest or merit. A *preliminary letter* is necessary.
Illustrations: Photos of current interest; occasional line.

REVIEW OF THEOLOGY AND PHILOSOPHY, Prof. Allan Menzies, D.D., *20, South Frederick Street, Edinburgh.*
This review is limited to notices, which are signed, of books on theology and philosophy appearing in this country or abroad. *Payment* at the rate of 5s. per page.

REYNOLDS' NEWSPAPER, W. M. Thompson, *Effingham House, Arundel Street, W.C.*
1d. W. (Sunday).—A people's paper of advanced views. Articles written in a necessary style to suit the paper may be sent for consideration. *Payment:* Usually one guinea per column.

ROSEBUD, Herbert Clarke, *13, Fleet Street, E.C.*
3d. M. (25th).—An illustrated magazine for children. Stories and articles of a suitable character not exceeding 500 words may be sent in. **Illustrations:** Line drawings and some half-tone blocks, full page and story illustrations suitable for very young children.

ROYAL MAGAZINE, *Henrietta Street W.C.*
4d. M. (22nd).—A bright illustrated magazine containing short stories, serials, articles and poems. Stories should be from 3,000 to 4,000 words. Articles on general subjects from 1,500 to 3,000, and should be suitable for illustration. A *preliminary letter* is not necessary.
Illustrations: Cover varies. Frontispiece, full pages, tail pieces, story and article illustrations in line, wash or photos. Illustrated jokes.

ROYAL ASIATIC JOURNAL, *22, Albemarle Street, W.*
12s. Q.—Illustrated. Original essays for translation on Oriental, literary and scientific matters are considered. A *preliminary letter* is desired.

RAILWAY JOURNAL, *St. Andrew, 68, Bath Street, Glasgow.*
1d. W. (Thursday).—

ST. NICHOLAS MAGAZINE, Mary Mapes Dodge, *Union Square, New York City.*
1s. M. (15th).—Contains stories and articles and some poems. A *preliminary letter* from contributors is optional. MSS. should be sent straight to above address with stamps for return in case it is necessary.
Illustrations: Cover varies. Frontispiece, full pages, tail pieces, story illustrations, black and white or colour, in line, wash, or photos, of interest to children. Original drawings being subject to tariff rates should not be sent without previous arrangement.

SANDOW'S MAGAZINE, Eugen Sandow, *131, Temple Chambers, Temple Avenue, E.C.*
2d. W.—

ST. JAMES'S BUDGET, *104, Shoe Lane, E.C.*
6d. W. (Friday).—Contains topical articles on current matters, reviews of books, and gossip of the week. As it is a summary of the articles and news contained in the *Evening Standard and St. James's Gazette* of the week, no original articles can be accepted.

SATURDAY REVIEW, Harold Hodge, *33, Southampton Street, Strand, W.C.*
6d. W. (Saturday).—A high-class journal, dealing chiefly with matters concerning literature, politics, science, and art. Suitable articles from 800 to 1,200 words may be sent for consideration. A *preliminary letter* is required. Rejected MSS. are not returned, and the Editor cannot enter into correspondence as to them.

SCHOOL, R. B. Lattimer, M.A., *50a, Albemarle Street, W.C.*
6d. M.—Articles should be, as a rule, under 2,500 words, and should deal with educational topics. Practical advice on teaching school subjects is especially welcomed; and educational politics, including such matters as the methods of the Board of Education, the powers of local authorities, the rights and responsibilities of teachers, etc., are special features of the paper.

SCHOOL GOVERNMENT CHRONICLE, Herbert Cornish, *21, New Bridge Street, E.C*
3d. W.—

SCHOOL WORLD, Prof. R. A. Gregory and A. T. Simmons, *St. Martin's Street, W.C.*
6d. M. (1st).—This magazine contains articles on teaching both at home and abroad, and is entirely devoted to educational matters. Any MSS. sent for consideration must be practical; and preference is given to articles by writers actively engaged in educational work. Length of a contribution should not exceed 2,500 words. *Payment,* about 15s. 1,000 words. A *preliminary letter* is desirable, but not necessary.

SCHOOLMASTER, T. J. Macnamara, M.P., *3, Racquet Court, Fleet Street, E.C.*
1d. W. (Saturday).—The organ of the National Union of Teachers; it contains notes, reports, short articles, etc., dealing with education in all its branches. No fiction or general articles.

SCHOOLMISTRESS, Howarth Barnes, *149, Fleet Street, E.C.*
1d. W. (Thursday).—A newspaper containing news, reports, etc., interesting to all engaged in the practical work of education. Short articles of exceptional or practical interest are admitted, but no fiction.

SCIENCE SIFTINGS, C. Hyatt-Woolf, *123, Fleet Street, E.C.*
1d. W. (Tuesday).—An illustrated journal dealing with any kind of popular science. Contributors may send in notes and articles on scientific matters, these must be written in a bright, popular manner, and the average length should be from 650 to 1,300 words. No *preliminary letter* is desired, but a stamped envelope should be enclosed with MS. for return. *Payment:* Varies from 5s. to 5 guineas per column.
Illustrations: Line, wash or drawings and photos of scientific interest.

SCOTS' LAW TIMES, *18, St. Giles Street, Edinburgh.*
6d. W. (Saturday).—Illustrated.

SCOTTISH HISTORICAL REVIEW, James MacLehose, *61, St. Vincent Street, Glasgow.*
2s. 6d. Q.—The *Scottish Historical Review* is devoted to history, archæology, and literature, with more particular reference to Scotland and the Bo·der.
Illustrations: Suitable for articles, or reproductions of old Charters are inserted.

SCOTTISH MOUNTAINEERING CLUB JOURNAL, W. Douglas (*hon.*), *9, Castle Street, Edinburgh.*
1s. Three times a year.—This journal is devoted to all aspects of Scottish mountaineering. Essays and news concerning that subject are contributed by members of the Club gratuitously. No *remuneration* is given to writers of papers.

SCOTTISH FIELD, *11, Bothwell Street, Glasgow.*
6d. M.—The Editor invites literary contributions, photographs, and sketches, and is prepared to consider crisp and interesting articles on current sporting topics. Publication of same must be regarded as the only evidence of acceptance. The articles submitted should, where possible, be accompanied by suitable photographs, free from liability for copyright. *Payment* is liberal, but varies with the merit of the matter supplied.

SCOTTISH REVIEW and Christian Leader, *Parkside Works, Edinburgh.*
W. (Thursday).—Articles on literary, religious and social subjects. Special attention paid to topics of interest to Scottish readers. Length of contributions: Up to 2,000 words.
Illustrations of current events (particularly in Scotland), and of social work, etc.

SCRAPS, A. W. Barrett, *Red Lion Court, Fleet Street, E.C.*
1d. W. (Thursday).—An illustrated humorous weekly, with articles on subjects of literary, general, and curious interest. MSS. may be sent in. Short, humorous stories of about 1,500 words preferred. A *preliminary letter* is desirable in the case of serial stories.
Illustrations: Humorous line sketches.

SECONDARY EDUCATION, 9, *Bedford Court Mansions, Bedford Square, W.C.*
3d. M.—

SELECT STORIES, *Allerton House, Ardwick Green, Manchester.*
1d. W. (Wednesday).—This contains short stories and serial tales which may be sent by outside contributors. It is advisable to send a *preliminary letter* in the case of serials.
Illustrations: Story illustrations, line.

SHOOTING TIMES, A. C. Bonsall, *72-76, Temple Chambers, E.C.*
2d. W.—

SIXPENNY MAGAZINE OF FICTION, *23, Henrietta Street, W.C.*
6d. (published according to anouncement).—Contains a complete novel of about 80,000 words. MSS. may be sent for approval. *Payment* on acceptance.

SKETCH, *198, Strand, W.C.*
6d. W. (Wednesday).—Stories from 2,000 to 3,000 words are considered, and it is specially desirable that these shall be of a light character. Short, well-illustrated articles are especially welcome. Also news paragraphs. No *preliminary letter* is required. *Payment:* 30s. per 1,000 words. *Remarks:* Only typewritten matter considered.
Illustrations: Cover designs for special numbers. Full pages, humorous drawings, story and article illustrations in line, wash or photos of places, events, or anything that may be considered curious or unusual.

SMART NOVELS, Mrs. Thorne, *11, Gough Square.*
1d. W. (Monday).—Contains a complete novel of 30,000 words, a serial, theatrical gossip, etc. Contributions of the ordinary novelette type are not wanted, but there is always an opening for really well written realistic stories, which have a strong love interest. A *preliminary letter* is required.

SMART SET, W. J. Thorold (Managing Director), *90-93, Fleet Street, E.C.*
1s. M.—Short stories of 2,000 to 5,000 words, short poems and jokes, may be sent in on approval; all contributions must be bright, modern, and free from all padding.

SOCIETY PICTORIAL, J. A W. Oliver, *5, Arundel Street, W.C.*
1d. W.—

SOLICITORS' JOURNAL, E. P. Mathers, *27, Chancery Lane, W.C.*
6d. W. (Friday).—

SOMETHING TO READ, *6, West Harding Street, E.C.*
1d. W.—Contains three complete stories about 16,000 words in length and a serial.
Illustrations: In line.

SOUTH AFRICA, E. P. Mathers, *Winchester House, E.C.*
6d. W. (Saturday).—This journal contains articles of interest and special news paragraphs concerning South Africa. MSS. from persons who know their subject should only be submitted.

SOUTH AMERICAN JOURNAL, C. Dunlop, *4, Budge Row, E.C.*
6d. W. (Saturday).—Contains articles relating to South and Central America and Mexico. A *preliminary letter* should be sent.

SOUTH LONDON PRESS, C. Reid, *Red Lion Court, E.C.*
1d. W.—

SPARE MOMENTS, F. A. Wickhart, *12, Fetter Lane, E.C.*
1d. W. (Saturday).—Complete stories of about 2,000 words are wanted. *Remarks:* One guinea each week is offered for the best short story.

SPEAKER, J. L. Hammond, *14, Henrietta Street, W.C.*
6d. W. (Saturday).—A journal devoted to politics, literature, science and art. It advocates the principles of the Liberal party. Really good articles by well-known writers who are authorities on their subject may be sent in, but promiscuous contributions are not invited.

SPECTATOR, J. St. Loe Strachey, *1, Wellington Street, Strand.*
6d. W. (Saturday).—Not much outside work is accepted, but articles of a suitable character will always be considered. *A preliminary letter* is not necessary.

SPHERE, Clement Shorter, *6, Great New Street, E.C.*
6d. W. (Friday).—An illustrated up-to-date magazine containing news, articles on topical matters, and some fiction. Contributions are not very cordially welcomed unless of special importance.
Illustrations: Cover designs for special numbers. Topical drawings in wash may be submitted.

SPORTING LIFE, William Will (Managing Editor), *27, St. Bride Street, E.C.*
1d. D.—

SPORTING TIMES, John Corlett, *52, Fleet Street, E.C.*
2d. W.—Occasionally humorous tales, about 1,200 words in length, are accepted, or batches of short humorous paragraphs. Contributors are asked to state what value they put on their work when sending in their copy.

SPORTSMAN, Shirley Byron Jevons, *139-140, Fleet Street, E.C.*
1d. D.—

STAGE, Lionel Carson, *16, York Street, W.C.*
2d. W. (Thursday).—Original and interesting articles on stage topics and recitations may be sent for the Editor's consideration. Special news from the provinces or abroad is sometimes required.

STANDARD, H. A. Gwynne, *104, Shoe Lane, E.C.*
1d. D.—Articles of special interest on current topics and news paragraphs are always considered. *Payment:* From one guinea per 1,000 words upwards.

STAR, *Stonecutter Street, E.C.*
½d. D.—Topical photographs are sometimes accepted.

STATIST, T. Lloyd; R. R. Mabson; George Paish, *51, Cannon Street, E.C.*
6d. W.—

STRAND MAGAZINE, H. Greenough Smith, *Southampton Street, Strand, W.C.*
6d. M. (1st).—A well-illustrated magazine, containing articles of general interest, short stories, serials, verses, etc. Short stories dealing with quaint and out-of-the-way experiences are generally preferred. Articles of general interest, especially such as lend themselves to illustration, are often acceptable. *A preliminary letter* is required. *Payment:* Liberal for good work.
Illustrations: Frontispiece, tail pieces, story and article illustrations in line, wash or photos.

STUDIO, C. Holme, *44, Leicester Square, W.C.*
1s. M. (15th).—A magazine dealing entirely with art matters (principally modern). Articles from 2,000 to 3,000 words on fine or applied art subjects may be sent for consideration. A *preliminary letter* is required. *Payment:* Usually one guinea per page. *Remarks:* Only illustrated articles are required.
Illustrations: Photographs and drawings of all kinds, black and white or colour, wash or line. Supplements.

SUN, John Sansome, *Temple Avenue, E.C.*
½d. D.—Short sketches written in a bright, popular style, or news of special interest, may be sent.

SUNDAY, *23, Paternoster Buildings, E.C.*
½d. and 3d. W. and M.—Good short stories between 1,000 or 1,200 words, and interesting articles between 800 or 1,000 words, suitable for children may be sent for consideration. No fairy tales or allegories required. *Remarks:* Prize competitions for young readers given monthly.
Illustrations: Line or wash drawings suitable for young readers.

SUNDAY AT HOME, *4, Bouverie Street, E.C.*
6d. M. (25th).—This magazine contains short stories, usually of a religious character, also serial tales. Illustrated articles of biography, travel, and philanthropic and religious effort, are standing features. A *preliminary letter* is not necessary.
Illustrations: Cover varies. Frontispiece, tail pieces, story and article illustrations in line, wash, or photos.

SUNDAY CHRONICLE, E. Hulton and Co., *Manchester.*
1d. W. (Sunday).—Short stories of about 3,000 words in length, humorous sketches of either 1,200 or 2,200 words, news, stories, and topical articles, illustrated by photographs, may all be submitted for approval. A *preliminary letter* is not desired. MSS. unaccompanied by a stamped directed envelope cannot be returned.

SUNDAY CIRCLE, Hartley Aspden, *Carmelite House, E.C.*
1d. W. (Tuesday).—A brightly illustrated paper chiefly from photographs, all of which are paid for at good rates. Short descriptive articles should accompany each photograph. Stories should be 3,000 words in length.

SUNDAY COMPANION, Hartley Aspden, *Carmelite House, E.C.*
1d W. (Thursday).—A religious journal. Paragraphs and articles suitable for it are paid for, also stories, which should not exceed 3,000 words.
Illustrations: In wash and line.

SUNDAY MAGAZINE, Hartley Aspden, *Carmelite House, E.C.*
6d. M.—Articles of travel, incident or religious interest, are required, also short stories of 4,000 words.
Illustrations: Story and article illustrations in line, wash, or photos.

SUNDAY SCHOOL CHRONICLE, Rev. Frank Johnson, *57, Ludgate Hill, E.C.*
1d. W. (Thursday).—Only serial stories are accepted from outside contributors. These should be suitable for home reading, and of a religious tone.

SUNDAY STORIES, Hartley Aspden, *Carmelite House, E.C.*
1d. W. (Wednesday).—The leading feature is a good healthy, moral story of human interest—nothing namby-pamby or goody-goody, yet full of human sweetness and incident. A strong love element should pervade each story.
Illustrations: In line.

SUNDAY STRAND, A. B. Cooper, *Burleigh Street Strand, W.C.*
 6d. M. (27th).—This magazine contains articles, short stories, some serials, and occasional verses. Bright, popular contributions are always gladly considered. No *preliminary letter* is required.
 Illustrations: Frontispiece, tail pieces, full pages, story and article illustrations in line, wash or photos.

SUNDAY SUN, *16, Serjeant's Inn, E.C.*
 1d. W (Sunday).—This paper contains special book reviews, and the latest news of the theatrical and sporting world.

SUNDAY TIMES AND SUNDAY SPECIAL, Leonard Rees, *7, Essex Street, W.C.*
 1d. W. (Sunday).—Contains news paragraphs and bright up-to-date articles on topical matters.

SURVEYOR AND MUNICIPAL AND COUNTY ENGINEER, Gibson Thompson, *24, Bride Lane, E.C.*
 3d. W. (Friday).—Articles of 2,000 to 3,000 words preferred. Technical matter confined to municipal engineering work desired. *Payment:* For literary contributions by arrangement.
 Illustrations: Photographs and (especially) engineering diagrams.

SYREN AND SHIPPING, Joseph L. Carozzi, *93, Leadenhall Street, E.C.* Illustrated.

TABLET, J. Snead-Cox, *19, Henrietta Street, Covent Garden, W.C.*
 5d. W. (Saturday).—A Catholic journal, which contains news of the week, articles on topics of the day, notes, reviews. Rejected MSS. cannot be returned unless accompanied by address and postage.

T.A.T., W. H. Maas, *6, West Harding Street, E.C.*
 1d. W.—Short stories (2,000 to 3,500 words), humorous stories (1,500 to 2,000), topical articles, accepted. *Payment* by arrangement. Press day ten days in advance. No illustrations.

TATLER, Clement Shorter, *6, Great New Street, E.C.*
 6d. W. (Saturday).—An illustrated weekly, which contains articles on current matters, occasional stories, and items of interesting news. Articles are not often accepted unless commissioned. A *preliminary letter* is advisable, except when the work is such as to require immediate attention.
 Illustrations: Cover designs for special numbers; humorous sketches only.

TEACHER, Sir Isaac Pitman and Sons, *1, Amen Corner, E.C.*
 1d. (Saturday).—

TEMPLE BAR, *St. Martin's Street, W.C.*
 6d. net. M. (25th).—This magazine contains well-written articles on matters literary, historical and biographical. Also some stories. Articles on suitable subjects are always considered. A *preliminary letter* is not indispensable.

THEOSOPHICAL REVIEW, Annie Besant; G. R. S. Mead, *161, New Bond Street, W.*
 1s. M.—The contents deal with Theosophy of every age and in every form. Articles, four to eight pages. Usually no *payment;* but occasionally terms arranged with contributors up to half a guinea a page (400 words).
 Illustrations: Diagrams.

THRILLING LIFE STORIES, *Allerton House, Ardwick Green, Manchester.*
 1d. W. (Thursday).—Original illustrated stories of life incident may be sent for consideration. A *preliminary letter* is not necessary.

TIMES, G. E. Buckle, *Printing House Square, E.C.*
3d. D.—Articles on special subjects of current interest written by those who are experts in their subject may be sent for consideration. No *preliminary letter* is required.

TIT-BITS, Galloway Fraser, *Southampton Street, Strand, W.C.*
1d. W. (Thursday).—Contains miscellaneous articles, numerous paragraphs, short stories from 1,500 to 2,400 words, and serials. Curious anecdotes and stories of startling out-of-the-way experiences are chiefly required. No *preliminary letter* is desired. *Payment:* One guinea per column; and two guineas per column for articles printed on a special page. *Remarks:* The Editor is always glad to consider contributions, and bright articles on new and interesting subjects are wanted.

TOWN TOPICS, W. J. Thorold (Managing Director), *90-93, Fleet Street, E.C.*
6d. W.—

T.P.'S WEEKLY, T. P. O'Connor, *5, Tavistock Street, W.C.*
1d. W. (Friday).—This paper contains articles on literary topics, serial stories, and short stories. A *preliminary letter* is not necessary, but advisable. *Remarks:* The paper is written chiefly in the office by the staff, except in the matter of fiction.

TRAVELLER'S MAGAZINE, *45, St. Martin's Lane, W.C.*
6d. M.—

TREASURY, Rev. A. Deane, *7, Portugal Street, Lincoln's Inn Fields, W.C.*
1d. M. (27th).—Short stories of about 4,000 words, and articles, especially those of interest to Church people, may be sent for consideration. No *preliminary letter* is required.
Illustrations: Frontispiece, tail pieces, full pages, story, and article illustrations in line, wash or photos. Occasional supplement.

TRIBUNE.
D.—A newspaper with literary and general articles.

TRUTH, Henry Labouchere and Horace Voules, *"Truth" Buildings, Carteret Street, Queen Anne's Gate, S.W.*
6d. W. (Wednesday).—A journal dealing chiefly with political and social matters, and containing one short story a week. The short stories are accepted from outside contributors. They should be written in a bright, almost racy, style, and should be from 2,000 to 3,000 words. A *preliminary letter* is optional.

UNION JACK LIBRARY, Hamilton Edwards, *2, Carmelite House, E.C.*
1d. W.—Good healthy adventure; sea; school; historical or foreign lands. Plenty of incident and no elaborate verbiage. All copy must be typewritten. Length, 36,000 words.

UNITED SERVICE GAZETTE, *43-44, Temple Chambers, E.C.*
6d. W. (Thursdays).—Naval and military articles (topical or technical) solicited. *Payment* by arrangement.

UNITED SERVICE MAGAZINE, Lt.-Colonel Alsager Pollock, *23, Cockspur Street, S.W.*
2s. M.—A review devoted to matters of Naval and Military interest. Articles should deal with naval or military topics of the day, naval or military history, strategy, tactics, drill, and naval or military administration. Short articles are preferred. Contributors who desire *payment* should state the amount of remuneration required.

UNITED TEMPERANCE GAZETTE, *28, Memorial Hall, Chambers, Farringdon Avenue, E.C.*
1d. M.—A journal dealing with all branches of the temperance question. Articles on this subject of special interest may be sent in. A *preliminary letter* is required.

UNIVERSITY REVIEW, *65, Long Acre.*
6d. M.—The Editor invites contributions, such as articles of academic and general interest on educational, scientific, and literary subjects; these are usually signed, and should be from 3,000 to 5,000 words, and may be illustrated with suitable photographs and drawings. Stamps must be enclosed for return where desired. No remuneration.

VANITY FAIR, B. Fletcher Robinson, *25, Strand, W.C.*
6d. W. (Wednesday).—A political and social journal, in which appear articles of interest to the Upper Classes, humour, light verse, and "Vain Tales," accepted. Prices by agreement.
Illustrations: Not required.

VERULAM REVIEW, *Harewood House, Milford-on-Sea.*
1s. Q.—The publication is chiefly concerned to point out the errors of physiological experimentation from the scientific standpoint. No remuneration. There are no illustrations.

WAR CRY, Fred. J. Moss, *101, Queen Victoria Street, E.C.*
1d. W.—
Illustrations: Line and wash drawings and photographs of subjects affecting the social life of the people.

WAR OFFICE TIMES, *124, Victoria Street, S.W.*
6d. M.—Contains short articles on military subjects, news notes, etc.; length about 1,500 words.

WEEKLY BUDGET, *Red Lion Court, E.C.*
1d. W. (Wednesday).—Contributors may send short stories, sketches and articles on suitable subjects, such as social matters, biography, etc. Also some serials. Stories and articles should be from 1,000 to 2,000 words. No *preliminary letter* is required. *Payment:* About £1 per column. *Remarks:* This is a family newspaper, and does not lend itself to the propagation of sensationalism. It is a popular journal. The type of stories required are love stories, thrilling romances, and narratives of adventure.
Illustrations: Stories and articles illustrated by line drawings; photos of topical interest.

WEEKLY DISPATCH, *3, Tallis Street, E.C.*
1d. W. (Saturdays and Sundays).—Articles on news of the week may be sent for consideration. No fiction required. *Payment:* A guinea per column. *Remarks:* Writers are most earnestly requested not to send in matter without first considering its suitability, and without stamped addressed envelopes for return in case of rejection. All matter sent in is carefully considered, though not invited. The *Weekly Dispatch* is a newspaper, and its contents are chiefly up to date news.
Illustrations: Photos, line, etc.

WEEKLY SCOTSMAN, *The Scotsman Buildings, Edinburgh.*
1d. W. (Saturday).—This paper contains special news items, also articles of special interest on current topics, short, interesting essays on natural history, literary subjects, etc., a serial story, and a short story of about 2,000 to 3,000 words.

WEEKLY TELEGRAPH, c/o Sir W. C. Leng and Co., *Sheffield.*
 1d. W. (Tuesday).—An illustrated paper for all classes, containing serial stories, complete stories, general articles, scientific and social notes. All MSS. submitted receive consideration. A *preliminary letter* is not necessary.
 Illustrations: Topical photos and line drawings.

WEEKLY TIMES AND ECHO, E. J. Kibblewhite, *Clement's Inn Passage, W.C.*
 1d. W. (Sunday).—This paper contains stories as well as news. A *preliminary letter* from contributors is desirable.
 Illustrations: Line only.

WEEK'S SURVEY, A. L. Haydon, *56, Ludgate Hill, E.C.*
 1d. W. (Friday).—Articles of about 1,000 words, dealing with matters of topical interest in Great Britain and the Colonies, or descriptive papers on natural history and other scientific subjects, are usually acceptable. *Remarks:* MSS. should be typewritten, and a stamped addressed envelope enclosed.

WESLEYAN METHODIST MAGAZINE, Rev. John Telford, B.A., *2, Castle Street, City Road, E.C*
 6d. M.—

WESTMINSTER GAZETTE, J. A. Spender, *Tudor Street, E.C.*
 1d. D.—The Editor is glad to consider short stories, general articles and sketches. A *preliminary letter* is not desired.

WESTMINSTER REVIEW, *51, Old Bailey, E.C.*
 2s. 6d. net. M.—Contains political and literary articles, varying from 4,000 words. These should be by those having special knowledge of the subjects on which they write.

WHITEHALL REVIEW, Fred. Horner, M.P., *15, King Street, Covent Garden, W.C.*
 6d. W.—

WIDE WORLD MAGAZINE, Victor Pit-Kethley, *Southampton Street, Strand, W.C.*
 6d. M. (22nd).—A magazine containing true stories of peril and adventure, articles on quaint and peculiar subjects, also those dealing with manners, sports, travel, and customs, and these must always be accompanied by a set of striking photos. A *preliminary letter* is not necessary.
 Illustrations: Photos of special interest, and intended for articles.

WINDSOR MAGAZINE, Arthur Hutchinson, *Warwick House, Salisbury Square, E.C.*
 6d. M.—An illustrated popular magazine, containing serial stories by leading novelists, short stories, articles, and verse. Careful consideration is given to all work submitted. A *preliminary letter* is not necessary.

WOMAN, Mrs. C. S. Peel; Miss F. M. Strutt-Cavell *(Acting Editor), 10, Fetter Lane, E.C.*
 1d. W. (Wednesday).—A paper devoted to such subjects as are of special interest to women. Short dramatic love stories, household articles and new ideas may be sent for consideration. No *preliminary letter* is required. *Payment* at the rate of 10s. 6d. per column. *Remarks:* The Editor always encourages new writers who show promise.

WOMAN AT HOME, *27, Paternoster Row, E.C.*
 6d. M. (20th).—A magazine containing articles and stories of special interest to women. A *preliminary letter* is optional.

WOMAN'S LIFE, Galloway Fraser, *Southampton Street, Strand, W.C.*
1d. W. (Tuesday).—This paper contains short stories of about 2,000 words, brightly written articles of a practical nature concerning domestic matters or of general interest. A *preliminary letter* is not required. *Payment:* Usually a guinea per 1,000 words. *Remarks:* Frequent prize offers open to all readers. Short stories are always welcomed.
Illustrations: Cover varies. Frontispiece, tail pieces, story and article illustrations in line, wash or photos.

WOMAN'S WORLD, Hamilton Edwards, *2, Carmelite House, E.C.*
1d. W.—Serial stories of strong domestic interest, 60,000 to 100,000 words. Short complete stories, 3,000 to 4,000 words in length. All copy must be typewritten.

WOMANHOOD, Mrs. Ada S. Ballin, *5, Agar Street, W.C.*
6d. M. (25th).—Stories of special intellectual value and original articles relating to the intellectual and political status of women only are accepted, and there is very little room available. A *preliminary letter* is essential.
Illustrations: Stories and articles illustrated in line, wash or photos.

WORK, Paul N. Hasluck, *La Belle Sauvage, E.C.*
1d. and 6d. W. and M.—This journal contains articles usually on technical subjects and written in a practical manner. A *preliminary letter* is not necessary.
Illustrations to articles; photos, line.

WORLD, *1, York Street, Covent Garden, W.C.*
6d. W. (Tuesday).—A high-class journal, devoted chiefly to social and current affairs. Short stories of 2,500 to 3,000 words, and dialogues of a thousand words are accepted from outside contributors, and must be bright and up-to-date. No *preliminary letter* is necessary.

WORLD AND HIS WIFE, *Carmelite House, E.C.*
6d. W.—Contains Society small-talk; short stories, about 4,000, and storyettes, about 1,000 words, in length. Also a serial, generally by a well-known writer.

WORLD OF DRESS AND WOMAN'S JOURNAL, Mrs. Waldemar Leverton, *4, Agar Street, W.C.*
6d. M.—Matter desired consists of articles of special interest to cultured women. *Payment:* Special articles a guinea a thousand words.
Illustrations: Line and wash fashion drawings, and photographs of celebrities or of any interesting function.

WORLD'S WORK AND PLAY, Henry Norman, M.P., *20, Bedford Street, W.C.*
1s. net. M. (25th).—Contributors may send general articles, especially upon new and interesting enterprises in any part of the British Empire. These should be illustrated by original photographs. A *preliminary letter* should be sent if possible. *Remarks:* MSS. should be typewritten, and be accompanied by stamps to pay return postage.
Illustrations: Photos.

YACHTSMAN, E. H. Hamilton, *143, Strand, W.C.*
3d. W. (Thursday).—A journal devoted to the interests of yachting and canoeing. The editor desires that contributions should be strictly limited to seafaring life.
Illustrations of marine subjects required.

YES OR NO, the Saturday Magazine, *11, Gough Square.*
1d. W. (Saturday).—Serials by known writers, and short stories. Contributions should be of from 500 to 5,000 words, dramatic, crisp, and powerful. They may be tales of adventure, crime, humour or love.

YORKSHIRE WEEKLY POST, *Leeds.*
1d. W. (Saturday).—An illustrated, family journal, with stories, articles on literary and social topics, notes and queries, and news of the week.
Illustrations: Articles illustrated by line.

YOUNG DAYS, J. J. Wright, *Essex Street, Strand, W.C.*
1d. M. (1st).—An illustrated unsectarian magazine for children and young people. Stories and articles of a suitable nature may be submitted, but the magazine is well supplied by the regular staff. No *preliminary letter* is required. First contributions not usually paid for.
Illustrations: Line, wash or photos to illustrate article or stories of interest to young people, but electros mostly used.

YOUNG ENGLAND, H. G. Groser, *57, Ludgate Hill, E.C.*
3d. M.—Contains serial tales, short stories, articles, and humorous verses. A *preliminary letter* is advisable only in the case of long stories for serials. *Remarks:* The journal is for boys of the educated class. Informative articles are freely used if brightly written.
Illustrations: Spirited drawings in line or wash.

YOUNG MAN, *4, Ludgate Circus, E.C.*
3d. M. (25th).—A journal containing all kinds of articles, personal sketches, items of news for Christian young men. A *preliminary letter* from contributors is advisable.

YOUNG PEOPLE, Rev. Ernest F. H. Capey, *23, Farringdon Avenue, E.C.*
1d. M. (25th).—A journal of distinctly religious character, containing tales of life at school, at home and abroad. Short stories not exceeding 2,000 words are acceptable. Small remuneration by arrangement. No *preliminary letter* is required. *Remarks:* Prizes offered for young authors in connection with the Literary Guild.
Illustrations: Humorous line drawings, story and article illustration in line, wash or photos. Full pages and tail pieces.

YOUNG WOMAN, *4, Ludgate Circus, E.C.*
3d. M. (25th).—Contributors may send short stories, between 3.000 and 4,000 words, sketches, interviews, and articles on religious and domestic subjects A *preliminary letter* is advisable.
Illustrations: Story and article illustration in line, wash or photos.

ZOOPHILIST, *20, Victoria Street, S.W.*
3d. M. (25th).—This journal is the organ of the anti-vivisection movement, and contains articles on literary and scientific matters. These should be of the length of two or three columns. Nothing that is not of considerable merit should be submitted. A *preliminary letter* is advisable.

PUBLISHERS

T.A. = *Telegraphic Address.* T. = *Telephone.*

ABBOT, JONES AND Co., LIMITED, 4 and 5, Adam Street, Strand, W.C. Educational and other works.

ALEXANDER AND SHEPHEARD, LIMITED, 21 and 22, Furnival Street, E.C. General Publishers.

ALLEN, GEORGE, Ruskin House, 156, Charing Cross Road, W.C. Publishers of books in every department of literature. T.A., Deucalion, London.

ALLENSON, H. R., 2, Ivy Lane, Paternoster Row, E.C. Religious works.

ALLMAN AND SON, LIMITED, 67, New Oxford Street, W.C. Educational publishers. T., 349 Central.

AMALGAMATED PRESS, LIMITED, THE, Carmelite Street, E.C. T.A., Mistitled, London.

APPLETON, D., AND CO., 25, Bedford Street, Strand, W.C. New York : 72, Fifth Avenue. General publishers, fiction, science, medicine, and poetry. T.A., Hilandero, London; T., 2295 Gerrard.

APPLETON, SIDNEY, 25, Bedford Street, W.C. General.

ARNOLD, EDWARD, 37, Bedford Street, Strand, W.C. General and Educational publisher. T.A., Scholarly, London.

ARNOLD, E. J., AND SON, LIMITED, Leeds. Chiefly educational works. T.A., Arnold, Leeds; T., 3333 Leeds Central; 1147 National.

ARROWSMITH, J. W., Bristol. General publisher. T.A., Arrowsmith, Bristol; T., 98 Bristol.

ASHER AND CO., 13, Bedford Street, Strand, W.C. General publishers. T.A., Aspiration, London.

BACON AND CO., 127, Strand, W.C. Maps. T.A., Definition, London.

BAGSTER, SAMUEL, AND SONS, LIMITED, 15, Paternoster Row, E.C. Bibles. T.A., Bagster, London.

BAILLIERE, TINDALL AND COX, 8, Henrietta Street, W.C. Medical. T.A., Bailliere, London; T., 4646 Gerrard.

BALE, JOHN, SONS AND DANIELSSON, 83, Great Titchfield Street, W. Medical.

BATSFORD, B. T., 94, High Holborn, W.C. Architecture.

BEETON AND CO., LIMITED, 10 and 11 Fetter Lane, E.C. Publish various periodicals.

BELL, GEORGE AND SONS, 4, 5, and 6, York Street, Covent Garden, W.C. Founded in 1840. Educational, theological, artistic, and general publishers. T.A., Bohn, London.

BEMROSE AND SONS, LIMITED, 4, Snow Hill, E.C. Chiefly theological and technical books, also some guide books. T.A., Bemrose, London; T., 576 Holborn.

BLACK, ADAM AND CHARLES, 4, 5 and 6, Soho Square, W.C. General and educational publishers. T.A., Biblos, London; T., 2679 Central.

BLACKIE AND SON, LIMITED, 50, Old Bailey, E.C. General and educational publishers. T.A., Glossarium, London.

BLACKWOOD, JAMES, AND CO., Lovell's Court, Paternoster Row, E.C. General, religious and historical literature.

BLACKWOOD, WILLIAM, AND SONS, 45, George Street, Edinburgh, and 37, Paternoster Row, London. General and Educational Publishers. Magazine, "Blackwood's Magazine." T.A., Maga, London.

BOUSFIELD AND CO., LIMITED, Norfolk House, Norfolk Street, W.C. General publishers.

BRADBURY, AGNEW AND CO., LIMITED, Bouverie Street, Fleet Street, E.C. T.A., Charivari, London; T., 28 Holborn.

BROADBENT, ALBERT, 19, Oxford Street, Manchester. General publisher.

BROWN, A., AND SONS, LIMITED, 5, Farringdon Avenue, E.C. Educational.

BROWNE AND NOLAN, LIMITED, 24, Nassau Street, Dublin Educational. T.A., Nolan, Dublin; T., 85 Dublin.

BURLEIGH, THOMAS, 376, 377, Strand, W.C. General publisher.

BURNS AND OATES, LIMITED, Granville Mansions, Orchard Street, W. Roman Catholic. T.A., Burns Oates, London; T., 1396 Padd.

BUTTERWORTH AND CO., 12, Bell Yard, Temple Bar, W.C. Legal publishers. T.A., Butterworth, London.

CAMBRIDGE UNIVERSITY PRESS, Ave Maria Lane, E.C. Publishers of the Bible and Prayer Book; also of other religious books, classics, history and science, school books, and some general literature. T.A., Cantibrigea.

CAMERON, FERGUSON, AND CO., 263, High Street, Glasgow.

CASSELL AND CO., LIMITED, La Belle Sauvage, Ludgate Hill, E.C.; Paris, New York, and Melbourne. General publishers. T.A., Caspeg, London; T., 1055 Holborn.

CHAMBERS, W. AND R., LIMITED, 47, Paternoster Row, E.C., and 339, High Street, Edinburgh. Founded in 1832. Publishers of educational works, works of reference, and periodical publications. T.A., Journal, London.

CHAPMAN AND HALL, LIMITED, 11, Henrietta Street, W.C. General publishers. Agents and publishers for the Science and Art Departments, South Kensington. T.A., Pickwick, London; T., 2711 Gerrard.

CHATTO AND WINDUS, 111, St. Martin's Lane, W.C. Founded in 1853 by John Camden Hotten. General publishers. T.A., Bookstore, London.

CHURCHILL, J. AND A., 7, Great Marlborough Street, W. Medical.

CLARENDON PRESS, See OXFORD UNIVERSITY PRESS.

CLARK, T. & T., 38, George Street, Edinburgh. Theological. T.A., Dictionary, Edinburgh; T., 398 Edinburgh.

CLARKE, JAMES, AND CO., 13 and 14, Fleet Street, E.C. General publishers of books and of "The Christian World," "The Literary World," etc.

CLIVE, W. B., AND CO., 157, Drury Lane, W C. Educational T.A., Tutorial, London.

CLOWES, W., AND SON, LIMITED, 7, Fleet Street, E.C. T.A., Clowes, London; T., 4558.

COLLINS, W., SONS AND CO., LIMITED, Bridewell Place, E.C. Educational and general publishers.

CONSTABLE, ARCHIBALD AND CO., LTD., Whitehall Gardens, S.W. General Publishers. Meredith's works, Nansen's "Furthest North," novels by Henry James, Maurice Hewlett, George Gissing, etc. T.A., Dhagoba, London.

COX, HORACE, Windsor House, Bream's Buildings, Chancery Lane, E.C. Some sporting books, travels, novels, etc., and of "The Queen," "The Field," etc. T.A., Field Newspaper, London; T., 239 Holborn.

DANVERS AND CO., 82, New Bond Street, W. Publishers of general literature.

DAWBARN AND WARD, LIMITED, 6, Farringdon Avenue, E.C. Publishers of various periodicals and technical handbooks. T., 1926 Avenue.

DEACON, CHARLES WILLIAM, AND CO., Charing Cross Chambers, Duke Street, W.C. General publishers. T.A., Handbook, London.

DEAN AND SON, LIMITED, 160a, Fleet Street, E.C. Well known for their juvenile books and works of reference, such as Debrett's Peerage and Coming Events. T.A., Debrett, London; T., 119 Holborn.

DEIGHTON, BELL AND CO., 13, Trinity Street, Cambridge. Works on theology, mathematics and general subjects.

DENT, J. M., AND CO., 29 and 30, Bedford Street, W.C. General publishers. T.A., Templarian, London.

DICKS, JOHN, 313, Strand, W.C. Cheap editions of novels and plays.

DIGBY, LONG AND CO., 18, Bouverie Street, Fleet Street, E.C. General publishers.

DIPROSE AND BATEMAN, Sheffield Street, Lincoln's Inn Fields, W.C. Chiefly fiction and some handbooks.

DOUGLAS, DAVID, 10, Castle Street, Edinburgh. General publisher.

DOWNEY AND CO., LIMITED, 12, York Street, Covent Garden, W.C. General publishers.

DRANE, HENRY, Salisbury House, Salisbury Square, E.C. General publisher.

DUCKWORTH AND CO., 3, Henrietta Street, W.C. General publishers. Founded in 1897. T.A., Ductarius, London.

DUFFY, J., AND CO., LIMITED, 15, Wellington Quay, Dublin. General publishers.

DULAU AND CO., 37, Soho Square, W. Foreign.

EYRE AND SPOTTISWOODE, Great New Street, and East Harding Street, E.C. New York: E. and J. B. Young and Co., 7-9, West 18th Street. Founded in 1767. Government printers and publishers; also publish numerous editions of the Bible, and some general publications. Publishers of "The Sphere" and "The Tatler." T.A., Spotless, London; T., 100 Holborn.

FRENCH, SAMUEL, LIMITED, 89, Strand, W.C. Dramatic publishers. The American house is at 26, West 22nd Street, New York.

FROWDE, HENRY, See OXFORD UNIVERSITY PRESS.

FUNK AND WAGNALLS CO., New York; 44, Fleet Street, E.C. General. T.A., Trepathic; T., 726 Holborn.

GALE AND POLDEN, LIMITED, 2, Amen Corner, Paternoster Row, E.C. Publishers of general literature. T.A., Picquets, London; T., 281 Cent., 94 Holborn.

GALL AND INGLIS, Paternoster Square, E.C., and 20, Bernard Terrace, Edinburgh. General publishers. T.A., Gall, Edinburgh; T., 6151 Edinburgh.

GARDNER, ALEXANDER, Paisley. General.

GARDNER, DARTON AND CO., 3, Paternoster Buildings, E.C. Magazines and literature for the young are the specialities of this firm. T.A., Publishers, London; T., 2713 Cent. P.O.

GAY AND BIRD, 22, Bedford Street, Strand, W.C. Founded in 1891. General publishers. Importers of American publications. T., 2481 Cent. P.O.

GIBBINGS AND CO., LIMITED, 18, Bury Street, W.C. Works of reference, travel and adventure, as well as general literature.

GILL, GEORGE AND SONS, LIMITED, 13, Warwick Lane, E.C. Educational. T., 1711 Central.

GILL, L. UPCOTT, Bazaar Buildings, Drury Lane, W.C. Periodicals, and books for amateurs and collectors. T.A., Bazaar, London; T., 3466 Gerrard.

GILL, M. H., AND SON, LIMITED, 50, O'Connell Street, Upper Dublin, Roman Catholic. T.A., Gill, Dublin; T., 365 Dublin.

GINN AND CO., Boston; 9, St. Martin Street, W. Educational. T.A., Pedagogy.

GOWANS AND GRAY, Glasgow. General publishers.

GREEN, WILLIAM, AND SONS, 18 and 20, St. Giles Street, Edinburgh. Chiefly legal and medical works. T.A., Viridis, Edinburgh; T., 766 Edinburgh.

GREENING AND CO., LIMITED, 20, Cecil Court, Charing Cross Road, W.C. Publishers of general literature, especially fiction.

GRESHAM PUBLISHING CO., THE, 34, Southampton Street, Strand, W.C. Chiefly works of reference by subscription. T.A., Literato, London; T., 545 Central.

GRIFFIN, CHARLES AND CO., LIMITED, 12, Exeter Street, Strand, W.C. Scientific, medical and general works.

GRIFFITH, FARRAN, BROWNE AND CO., LIMITED, 35, Bow Street, Covent Garden, W.C. General publishers. T.A., Yardfar, London.

GURNEY AND JACKSON, 1, Paternoster Row, E.C. Chiefly works on natural history and science.

HACHETTE AND CO., 18, King William Street, Charing Cross, W.C. Publishers of works for the study of modern languages.

HARPER AND BROTHERS, 45, Albemarle Street, W. General. T.A., Harkspel, London; T., 2085 Gerrard.

HARRISON AND SONS, 59 Pall Mall, W. Works of reference. T., 4112 Gerrard.

HAZELL, WATSON, AND VINEY, LIMITED, 52, Long Acre, W.C. Publishers chiefly of technical works, specially photography and science. T.A., Plaintiff, London; T., 2076 Gerrard.

HEATH, D. C., AND CO., 15, York Street, W.C. Educational.

HEINEMANN, WILLIAM, 20 and 21, Bedford Street, Strand, W.C. General publishers. T.A., Sunlocks, London; T., 2279 Gerrard

HEYWOOD, JOHN, Deansgate and Ridgefield, Manchester; also 29 and 30, Shoe Lane, London. Educational, historical, and general publisher. T.A., Books, Manchester.

HIRSCHFELD BROTHERS, 13, Furnival Street, W.C. Foreign languages. T.A., Hirschfeld, London.

HODDER AND STOUGHTON, 27, Paternoster Row, E.C. Theological, fiction, and general. Publishers of "The British Weekly" and "The Bookman." T.A., Expositor, London; T., 920 Holborn.

HODGE, WILLIAM, AND CO., 34-36, North Frederick Street, Glasgow. General publishers.

HOULSTON AND SONS, Paternoster Square, E.C. Publishers of religious, juvenile, and other books. T.A., Houlston, London.

HURST AND BLACKETT, LIMITED, 182, 183, 184, High Holborn, W.C. Founded in 1807. Publishers of general literature. T., 2280 Central.

HUTCHINSON AND CO., 34, 35, and 36, Paternoster Row, E.C. General publishers, exporters to India, America, and the Colonies. T.A., Literarius, London; T., 733 Holborn.

ILIFFE AND SONS, LIMITED, 3, St. Bride Street, E.C. Publishers of various periodicals and guide books. T.A., Cyclist, London; T., 1731 Holborn.

JACK, T. C. AND E. C., Causewayside, Edinburgh, and 34, Henrietta Street, W.C. Standard works in belles-lettres, art, music, heraldry, and general. T.A., Octavo, Edinburgh; T., 724 Edinburgh.

JARROLD AND SONS, 10 and 11, Warwick Lane, E.C. General publishers. T.A., Jarrolds, London.

JOHNSON, R. BRIMLEY, AND INCE, 8, York Buildings, Adelphi, W.C. Poetry, modern drama, reprints, etc. T.A., Shamois, London.

JOHNSTON, W. & A. K., LIMITED, 7, Paternoster Square, E.C.; and Edina Works, Edinburgh. Maps. T.A., Edina, Edinburgh, and Geographers, London.

KELLY, CHAS. H., 2, Castle Street, City Road, E.C. Theological.

KING, P. S., AND SON, 2 and 4, Great Smith Street, W. General.

LAMLEY AND CO., 1, Exhibition Road, S.W. General.

LANE, JOHN, The Bodley Head, Vigo Street, W., and 251, Fifth Avenue, New York. Publisher of belles-lettres. T.A., Bodleian, London; T., 4467 Gerrard.

LAURIE, THOS., 13, Paternoster Row, E.C. Educational.

LAURIE, T. WERNER, 13, Clifford's Inn, E.C. General.

LAWRENCE AND BULLEN, LIMITED, 16, Henrietta Street, W.C. General publishers. T.A., Decameron, London.

LEADENHALL PRESS, LIMITED, THE, 50, Leadenhall Street, E.C. Miscellaneous publishers.

LEWIS, H. K., 136, Gower Street, W.C. Medical.

LIPPINCOTT CO. (J. B.), 5, Henrietta Street, W.C. The London office of the J. B. Lippincott Company, of Washington Square, Philadelphia, Pa., U.S.A. Manager, Mr. J. Garmeson.

LOCKWOOD (CROSBY) AND SON, 7, Stationers' Hall Court, E.C. Scientific. T., 4421 Cent. P.O.

LONG, JOHN, 13 and 14, Norris Street, Haymarket, S.W. General publishers, making a speciality of fiction. T.A., Longing, London; T., 9313 Central.

LONGMANS, GREEN, AND CO , 39, Paternoster Row, London, E.C.; 91-93, Fifth Avenue, New York; and 32, Hornby Road, Bombay. Founded 1724. Publishers of books in all departments of literature. T.A., Longmans, London.

LUZAC AND CO., 46, Great Russell Street, W.C. Oriental. T.A., Obfirmate.

MACDOUGALL'S EDUCATIONAL CO., LIMITED, 24, Warwick Lane, E.C.

MACLEHOSE, J., AND SONS, 61, St. Vincent Street, Glasgow. General. T., 3146 Nat., and 2416 Corp. (Glasgow).

MACMILLAN AND CO., LIMITED, St. Martin's Street, W.C. America : The Macmillan Co., New York. Publishers in all branches of literature. Publish magazines and journals, and for Rudyard Kipling, Marion Crawford, etc. T.A., Publish, London; T., 2686 Gerrard.

MARLBOROUGH, E., AND CO., 51, Old Bailey, E.C. Educational, general and religious literature. T.A., Marlborough, London.

MARSHALL, HORACE AND SON, Temple House, Temple Avenue, E.C., and Fleet Street, E.C. General publishers and wholesale booksellers.

MATHEWS, ELKIN, Vigo Street, W. Poetry.

MEIKLEJOHN AND HOLDEN, 11, Paternoster Square, E.C. Educational.

MELROSE, ANDREW, 16, Pilgrim Street, E.C. Publisher of devotional and general literature.

METHUEN AND CO., 36, Essex Street, Strand, W.C. Founded 1889. Publishers of all classes of literature, fiction, poetry, travel, historical, biographical, education, etc. T.A., Elegiacs, London.

MORGAN AND SCOTT, 12, Paternoster Buildings, E.C. Religious. T.A., Millenium, London; T., 1965 Holborn.

MORING, ALEXANDER, LIMITED, 32, George Street, Hanover Square, W. T., 2037 Mayfair.

MORTON, GEORGE A., 42, George Street, Edinburgh. General.

MURRAY, JOHN, 50, Albemarle Street, W. Founded in 1768. Publishers of many educational works and of the "Quarterly Review," the "Monthly Review," etc. T.A., Guidebook, London.

NASH, J. EVELEIGH, Bedford Street, Strand, W.C. General publisher. T., 5996 Central.

NELSON, THOMAS, AND SONS, 35 and 36, Paternoster Row, E.C. General literature, particularly educational, and books for children. T.A., Nelsons, Publishers, London; T., 1313 Cent. P.O.

NEWNES, GEORGE, LIMITED, 7-12, Southampton Street, W.C. General publishers. T.A., Newnes, London; T., 1495 and 2841 Gerrard.

NIMMO, HAY AND MITCHELL, 18, Clyde Street, Edinburgh. Reward books and uncopyrighted classics. T , 186 Edinburgh.

NISBET, JAMES AND CO., LIMITED, 21 and 22, Berners Street, W. Religious and general literature. T.A., Didactic, London; T., 2335 Gerrard.

NISTER, E., 24, St. Bride Street, E.C. Fine art books, especially for juveniles. T.A., Acquiesce, London.

NUTT, DAVID, 57, Long Acre, W.C. General.

OLIPHANT, ANDERSON AND FERRIER, 21, Paternoster Square, E.C., and at Edinburgh. Travel and missionary works, as well as fiction and books for the young. T.A., Publishing, Edinburgh, and Publiant, London; T., 1528 Cent. P.O.

OLIVER AND BOYD, Tweeddale Court, Edinburgh. Educational.

OXFORD UNIVERSITY PRESS, THE, St. Dunstan's House, Fetter Lane, E.C. Publishers chiefly of educational and religious works and books of reference. T.A., Froude; T., 99 Holborn.

PARTRIDGE, S. W., AND CO., 8 and 9, Paternoster Row, E.C. Founded in 1837. General Publishers. T.A., Pictorial, London; T., 619 Holborn.

PASSMORE AND ALABASTER, 4, Paternoster Buildings, E.C. T.A., Alamores, London; T., 1856 London Wall.

PAUL (KEGAN), TRENCH, TRUBNER, AND CO., LIMITED, Dryden House, 43, Gerrard Street, W. General, scientific, theological, and military publishers. T.A., Columnæ, London; T., 6164 Gerrard.

PEARSON, C. ARTHUR, LIMITED, 18, Henrietta Street, W.C. General literature, including many periodicals. T.A., Humoursome, London; T., 5161 and 4065 Gerrard.

PENTLAND, YOUNG, J., Edinburgh; 38, West Smithfield, E.C. Medical. T.A., Pentland.

PHILIP, GEORGE, AND SON, LIMITED, 32, Fleet Street, E.C. Educational. T.A., Education, Liverpool.

PITMAN, SIR ISAAC, AND SONS, with which is incorporated ISBISTER AND CO. General. 1, Amen Corner, E.C.

PUTNAM'S SONS, G. P., 24, Bedford Street, W.C., and New York. General publishers. T.A., Putnam, London.

RATIONALIST PRESS ASSOCIATION, LIMITED, 17, Johnson's Court, Fleet Street, E.C. Chiefly philosophical or scientific works.

REBMAN, LIMITED, 129, Shaftesbury Avenue, W.C. Medical. T.A., Squama; T., 2026 Gerrard.

REEVE, L., AND CO., LTD., 6, Henrietta Street, W.C. Natural history.

RELFE BROS., LIMITED, 6, Charterhouse Buildings, E.C. Educational. T.A., Relfe Bros., London; T. 4673 Holborn.

RELIGIOUS TRACT SOCIETY, 56, Paternoster Row, E.C. T.A., Tracts, London; T., 927 Holborn.

REVELL, FLEMING H., CO., 21, Paternoster Square, E.C.; and at Edinburgh, New York, etc. General literature, including fiction, juvenile books, works of travel, etc. T.A., Publiant, London.

RIVERS, ALSTON, LIMITED, Arundel Street, W.C.

RIVINGTONS, 34, King Street, Covent Garden, W.C. Educational and theological publishers. T.A., Perduro, London; T., 44531 Gerrard.

ROBINSON, F. E., AND CO., 20, Great Russell Street, W.C. General literature, but especially historical works.

ROUTLEDGE, GEORGE, AND SONS, LIMITED, Broadway House, Ludgate Hill, E.C. Founded 1835. Publishers and exporters of standard and modern literature, prize series reward books, etc. Managing Directors, Wm. Swan Sonnenschein and Laurie Magnus, M.A. T.A., George Routledge, London; T., 5730 Bank.

SANDS AND CO., 12, Burleigh Street, Strand, W.C. General publishers. T.A., Assiduous, London.

SCHULZE AND CO., 20, South Frederick Street, Edinburgh. General literature.

SCOTT, WALTER, PUBLISHING CO., LIMITED, 1, Paternoster Buildings, Paternoster Square, E.C., and Editorial Offices and Works at Felling, Newcastle-on-Tyne. General publishers, including: "Scott Library," "Great Writers' Series," "Contemporary Science Series," "Canterbury Poets," "Makers of British Art," etc. T.A., Comprend, London.

SEALY, BRYERS AND WALKER, 94, 96, Middle Abbey Street, Dublin. General literature. T.A., Thom, Dublin; T., 321 Dublin.

SEELEY AND CO., LIMITED, 38, Great Russell Street, W.C. Religious, educational, and general literature.

SHAW, JOHN F., AND CO., 48, Paternoster Row, E.C. Religious and books for the young. T., 2082 Central.

SIMPKIN, MARSHALL, HAMILTON, KENT, AND CO., Limited, 4, Stationers' Hall Court, E.C. Publishers for a great many authors, with an immense business as wholesale booksellers. T.A., Simpkin Marshall, London.

SKEFFINGTON AND SON, 34, Southampton Street, Strand, W.C. General publishers. T.A., Language; T., 7435 Central.

SMITH, ELDER, AND CO., 15, Waterloo Place, S.W. Published for Thackeray, the Brownings, Charlotte Brontë, George Eliot, etc.; also the "Cornhill Magazine." T.A., Senones, London.

SOCIETY FOR PROMOTING CHRISTIAN KNOWLEDGE, Northumberland Avenue, W.C. Works of every kind such as would promote Christian knowledge. T.A., Christian Knowledge, London.

SONNENSCHEIN (SWAN) AND CO., LIMITED, Paternoster Square, E.C. Founded in 1878 by Mr. Swan Sonnenschein. The business was converted into a private limited liability company in 1895. General publishers. Books for elementary and secondary school use, with a large number of University books in science, philology, and history; also the "Social Science Series." T.A., Sonnenschein, London.

SPON, E. AND F. N., LIMITED, 125, Strand, W.C. Technical works on all scientific subjects. T.A., Spon, Strand, London.

SPOTTISWOODE AND CO., LIMITED, 54, Gracechurch Street, and New Street Square, E.C. "Church Quarterly Review," and nautical and shipping publications. T.A., Spotleigh, for Gracechurch Street; and Spottiswoode, for New Street Square.

STANFORD, E., 12, Long Acre, W.C. Geographical. T.A., Zeitgeist; T., 4284 Gerrard.

STEVENS AND HAYNES, 13, Bell Yard, Temple Bar, W.C. Law. T.A., Polygraphy.

STOCK, ELLIOT, 62, Paternoster Row, E.C. Antiquarian.

SUNDAY SCHOOL UNION, 57 and 59, Ludgate Hill, E.C. Sunday School books of every description. T.A., Bookful, London; T., 775 Bank.

SWEET AND MAXWELL, LIMITED, 3, Chancery Lane, W.C. Legal. T.A., Subjicio, Eaton; T., 1008 Holborn.

THACKER, W., AND CO., 2, Creed Lane, Ludgate Hill, E.C. Indian law books, sporting and general literature. T.A., Mofussil, London.

TREHERNE, ANTHONY, AND CO., LIMITED, 3, Agar Street, Strand, W.C. Publishers of general fiction, sixpenny editions, books on sports, etc. T., 3475 Gerrard.

UNWIN, T. FISHER, 11, Paternoster Buildings, E.C. Books of travel, histories, and general literature are published by this firm, but it is best known for fiction. T.A., Century, London; T., 181 Central P.O.

WARD, LOCK AND CO., LIMITED, Warwick House, Salisbury Square, E.C. Incorporated in this business are the businesses of S. O. Beeton, Messrs. E. Moxon and Son, W. Tegg and Co., and A. D. Innes and Co., and other houses. Publishers of Beeton's Cookery and Gardening Books, Haydn's Dictionary of Dates, the Lily series, and novels by Anthony Hope, S. R. Crockett, Stanley Weyman, H. G. Wells, Max Pemberton, Joseph Hocking, etc. T.A., Warlock, London; T., 75 Holborn.

WARD (ROWLAND), LIMITED, 166, Piccadilly, W. Books dealing with sport and travel. T.A., Jungle, London.

WARNE, FREDERICK, AND CO., Chandos House, Bedford Street, W.C., and 103, Fifth Avenue, New York. Publishers of standard and illustrated works in general literature, etc. T.A., Warne, London; T., 2208 Gerrard.

WASHBOURNE, R. AND T., 3, Paternoster Row, E.C. Roman Catholic.

WELLBY, PHILLIP, 6, Henrietta Street, W.C. Publishers of works of fiction, philosophy, poetry and biography.

WHITAKER, J., AND SONS, LIMITED, 12, Warwick Lane, E.C. T., 1812 Holborn.

WHITE, F. V., AND CO., 14, Bedford Street, Strand, W.C. Publish general literature, and numerous novels by popular writers. T.A., Playbook, London.

WHITTAKER AND CO., 2, White Hart Street, Paternoster Square, E.C. Scientific and educational.

WILLIAMS AND NORGATE, 14, Henrietta Street, W.C. Theological and Theosophical. T.A., Librarum, London.

WILSON, FREDERICK W., AND CO., 93, Hope Street, Glasgow. Fiction, poetry, history, and general literature.

WILSON, EFFINGHAM, 11. Royal Exchange, E.C. T.A., Effingere, London.

WITHERBY AND CO., 326, High Holborn, W.C. Scientific, historical, naval books are published by this firm, and some periodicals.

AMERICAN PUBLISHERS

APPLETON, D., AND CO., 72, Fifth Avenue, New York. Scientific and educational works, and also fiction.

DODD, MEAD, AND CO., 372, Fifth Avenue, New York. Publishers of general literature.

DOUBLEDAY, PAGE, AND CO., 34, Union Square East, New York. General publishers, especially books on natural history.

HARPER BROTHERS, Frankland Square, New York.

HOLT AND CO., HENRY, 29, West Twenty-third Street, New York. General and educational publishers.

HOUGHTON, MIFFLIN, AND CO., 4, Park Street, Boston. Publishers of belles-lettres, and also of poetical works.

LIPPINCOTT, J. B., CO., Washington Square, Philadelphia. Educational, scientific, medical, and general publishers.

LITTLE, BROWN AND CO., Boston.

LOTHROP PUBLISHING CO., 530, Atlantic Avenue, Boston. Chiefly publish fiction and books for the young.

McCLURE, PHILLIPS, AND CO., 141, East Twenty fifth Street, New York. General publishers.

McCLURG, A. C., AND CO., 215, Wabash Avenue, Chicago. General publishers, including fiction, juvenile books, history, etc.

MACMILLAN, THE, COMPANY, 66, Fifth Avenue, New York. General and Educational Publishers.

PUTNAM'S, G. P., SONS, 27, West Twenty-third Street, New York. General publishers, especially history, science, etc.

SCRIBNER'S, CHARLES, SONS, 155, Fifth Avenue, New York.

STOKES CO., FREDERICK A., 5 and 7, East Sixteenth Street, New York. General publishers, specially fiction and juvenile books.

COLOUR PRINTERS, POSTER AND SHOW CARD, XMAS CARD AND PICTORIAL POST CARD FIRMS

ARMITAGE AND IBBETSON, Scott Hill Works, Bradford, and 11, Newgate Street, E.C.

ARMITAGE, A., Barker Gate, Nottingham.

ADAIR, HUGH, 9, Arthur Street, Belfast.

ARCHER, W. C., 51, Paternoster Row, E.C.

ATKINSON, A. H., 11, Dyer's Buildings, Holborn, E.C.

ANAKER, O., 2, Gresham Buildings, Basinghall Street, E.C.

ART IN COMMERCE CO., LIMITED, Long's Court, Leicester Square, W.

ALLEN, DAVID, AND SONS, 48, West Regent Street, Glasgow.

BERRY, W., AND CO., 13, Currer Street, Bradford, and 113, York Street, Manchester.

BEMROSE BROS., Irongate, Derby.

BIRN BROS., 67, Bunhill Row, E.C.

BARCLAY AND FRY, The Grove, Southwark Street, E.C.

BRAND, J., AND CO., Newbury Street, Cloth Fair.

BRUMBY AND CLARKE, 5, Farringdon Avenue, and Prospect Street, Hull.

BAIRD, ALEX., AND SON, 431, Great Western Road, Glasgow.

BAIRD, A. C., 72, Aldersgate Street, E.C.

BOLLENS, E., AND CO., Ranelagh Works, Leamington.

BLACKLOCK, HENRY, AND CO., 12, Albert Street, Manchester.

BROWN AND RAWCLIFFE, LIMITED, Exchange Works, Pall Mall, Liverpool.

BUSHELL, A., AND CO., Riverside Printing Works, Princess Street, Manchester.

BROWN, J., 22, Duke Street, Aldgate.

BRYANT, J., AND CO., 162, Bermondsey Street, E.C.

BECK AND CO., 65, Fore Street, E.C.

BERNHART AND CO., 66, Finsbury Pavement, E.C.

BLUM AND DEGEN, 28, Paternoster Row, E.C.

BLADES, EAST AND BLADES, 23, Abchurch Lane, E.C.

BRIGHTMAN, J., 68, Aldersgate Street, E.C.

COOKE, ALF., Crown Point Printing Works, Leeds.

CLARKE, F. W. S., 31, Rutland Street, Leeds.

CARVELL, W., AND CO., 47, Moseley Street, Manchester.

CRESSWELL AND OATSFORD, St. Mary's Place, Nottingham.

COLLINS AND KINGSTON, Southgate, King's Street, Manchester.

CLELAND, JOHN, Great Victoria Street, Belfast.

CAUSTON, SIR JOSEPH, AND SON, LIMITED, 9, Eastcheap, E.C.

CLARKE, S. J., 69, Milton Street, Fore Street.

CARR AND MASON, Brunswick Works, Leamington.

CAMPBELL AND TUDHOPE, 45, Cranston Street, Cranston Hill, Glasgow.

CHALMERS, JOHN, Bindloss Chambers, 4, Chapel Walks, Manchester.

CHAMPENOIS AND CO., 12, Stonecutter Street, E.C., and Paris.

COUPER AND ALLEN, Kirkcaldy.

CASH AND CLARE, 75, Great Eastern Street, E.C.

CLARKSON BROS., 128, Charing Cross Road.

CAUNT, JOHN, 19, Russell Street, Leeds.

CORNWALL, G., AND SONS, 42, Castle Street, Aberdeen.

CYNICUS PUBLISHING CO., Broad Street, Tayport, Fifeshire.

CULLIFORD AND SONS, Fulward's Rents, Oxford Street, W.C.

DAVENPORT, J. H., AND CO., St. Columbia Street, Leeds.

DAVIS, W., AND SONS, 5, Edgbaston Street, Birmingham.

DEVITT AND RODGERS, Stratford Road, Birmingham.

DAVIES, ALLEN, AND CO., Nelson Street, Bristol.

DAVIDSON AND BROS., Marlborough House, Basterfield Street, Golden Lane, E.C.

DEAN AND SON, 160a, Fleet Street, E.C.

DELGARDO, G., 55, East Road, City Road, N.

DORENDORFF AND CO., 5, Worship Street, E.C.

DE LA RUE, THOS., AND CO., Bunhill Row, E.C.

DEVITT, W., AND CO., 22, George Street, Manchester.

EDLER AND KRISCHE (Hanover), Agent, Richard Wenzel, 67, Bunhill Row, E.C.

EMRICK AND BINGER (Holland), 379, Strand, W.C.

EYRE AND SPOTTISWOODE, Gt. New Street, Fetter Lane, E.C.

FORMAN, THOS., AND SONS, Nottingham, and 59, Vincent Street, Glasgow.

FRASER, G., AND CO., College Lane, Liverpool.

FAULKNER, C. W., AND CO., 41, Jewin Street, E.C.

FAIRHEAD, THOS., CLAUDE, (Agent), 34, Paternoster Row, E.C.

FOOT, JOHN TAYLOR, 18, Poland Street, Oxford Street, W.

FORREST AND SON, 355, Argyle Street, Glasgow.

GOODALL AND SUDDICK, Cookridge Street, Leeds.

GOATER, ALFRED, Mount Street Works, Nottingham.

GREINER, G., AND CO., 10, Milton Street, Cripplegate, E.C.

GEORGE, BEN, 47, Hatton Garden, E.C.

GOODE BROS., 48, Clerkenwell Green, E.C.

GOW, ALEX., AND CO., 27, New Bridge Street, E.C.

GALE AND CO., 145, Cambridge Road, E.

GROSE, T. V., 254, Ferndale Road, Brixton Road, S.W.

GAINES, W. AND T., Bankfield Works, Leeds.

GIESEN BROS., 28, Monkwell Street, E.C.

HORROCKS AND CO., Ashton-under-Lyne.

HUDSON, SCOTT AND SONS, James Street Works, Carlisle.

HOWETT, J., AND SON, 16, Clumber Street, Nottingham.

HOLT, CHAS., AND CO., Siddals Road Mills, Derby.

HAMILTON, ED., 56, Carter Lane, E.C.

HILDESHEIMER, S., AND CO., 96, Clerkenwell Road, E.C.

HILLS AND CO., 2, Bayer Street, Golden Lane, E.C.

HART AND CO., Fulward's Rents, Oxford Street, W.

HODGES, G. W., 23, Charter House Buildings, E.C.

HARRISON, TOWNSEND AND CO., Sovereign Street, Leeds.

HAGELBERG, W., 12, Bunhill Row, E.C.

HARTMANN, F., 45, Farringdon Street, E.C.

HORLE, FERD., ANTHONY AND CO., 8, St. John's Lane, E.C.

HUARDEL, P. G., AND CO., 295, High Holborn, W.C.

JOWETT AND SOWRY, 78, Albion Street, Leeds.

JOHNSON, J., AND CO., Challenge Printing Works, Northampton.

JOHNSON, H. J., AND CO., Adelaide Works, Hardcastle Street, Belfast.

JENKINSON AND CO., 9, Bartholomew Row, Birmingham.

JOHNSON, A. J., Express Works, Northampton.

JONAS, M. L., WOLF, AND CO. (Paris), 12, Stonecutter Lane, E.C.

JOHNSON, C. H., Leeds.

JOHNSTON, W., 7, Paternoster Square, E.C.

KAUFMANN, E., 5, Paternoster Square, E.C.

KING, J., 304, Essex Road, N.

KRAPPEK, G. A., AND CO., 34, Paternoster Row, E.C.

KRONHEIM, J. M., AND CO., 109, Hamilton House, Bishopsgate Street Without, E.C.

KALN, JULIUS, 131, Bunhill Row, E.C.

KEW, C. A., 4, Hesse Terrace, Commercial Road, S.E.

LLOYD AND TAYLOR, 77, Market Street, Manchester.

LIGHTON, A., 104, Eyre Street, Sheffield.

LETTS, CHARLES, AND CO., 3, Royal Exchange.

LANDSTEIN AND CO., 15, Carthusian Street, Aldersgate, E.C.

LONGWORTH, G. H., AND CO., 68, Mayor Street, Manchester.

LAW, R. C., Trumpet Street, Manchester.

LEEMING, RAY AND CO., 43, Lower Losley Street, Manchester.

LANDOU BROS., 157, Waterloo Road, E.C.

LANDEKER AND BROWN, 28, Worship Street, E.C.

LEWER, W. H., 28, Warwick Lane, E.C.

LYON, W., 31, Paternoster Square, E.C.

LONDON ARTISTIC CARD CO., 199, Upper Thames Street, E.C.

M'CAW, STEVENSON AND ORR, Linenhall Works, Belfast, and John Bright Street, Birmingham, and 93, Hope Street, Glasgow.

MILLAR AND LANG, 5, Robertson Street, Glasgow, and 34, Paternoster Row, E.C.

McKENZIE, W., AND CO., 48, Banner Street, E.C.

MASON, A., AND CO., Butler Street, E.C.

MENDELSSOHN, A., 17, Silk Street, E.C.

MISCH AND STOCK, 1, Cripplegate Street, E.C.

MIDDLETON, W. J , Adelphi Works, Aberdeen.

MORGAN AND McQUIRE, 10, Dyer's Buildings, E.C.

MEISSNER AND BUCH, 121, Bunhill Row, E.C.

McFARLANE AND ERSKINE, 14, St. James' Square, Edinburgh.

M'LAGAN AND CUMMING, Warriston Road, Edinburgh.

MALAMMA, N., AND CROMPTON, Trumpet Street, Manchester.

MOSTYN, E., AND CO., 44, Granby Row, Manchester.

MACPHAIL AND CO., 219, Argyle Street, Glasgow.

MERISON, JOHN, 6, Great Eastern Street, E.C.

MARTIN, CHAS., 14, Paternoster Row, E.C.

MITCHELL AND SHELLY, 101, Tollington Road, N.

MOSS, HENRI AND CO., 8, Cheapside, E.C.

NEIL, JOHN, Gt. John Street, W.C.

NISTER, E., 24, St. Bride Street, E.C., and Ambersly House, Norfolk Street, E.C.

NATHAN, D., AND CO., 15, Hereford Road, Westbourne Grove, W.

NATHAN, M. H., AND CO., 24, Australian Avenue, E.C.

NATZIO, A. E., AND CO., 48, Geanby Road, Manchester.

NIMMO, W., AND CO., 46, Constitution Street, Leith.

OPPENHEIMER, J., AND CO., 103, Newgate Street, E.C.

PORTER, N., AND SON, 63, Cannon Street, Manchester.

PEARSON, CYRUS, Bridlesmith Gate, Nottingham.

PURBROOK AND EYRES, 96, Old Street, E.C.

PHILIPS, SANDERS AND CO., 7, Upper Thames Street, E.C.

PICKFORD AND CO., LIMITED, 77, Southwark Street, E.C.

PUGSLEY, J. F., Cromwell Road, Bristol.

PAINE, SYDNEY, AND CO., 3, St. George's Avenue.

PICTORIAL POST CARD COMPANY, 44, Moor Lane, E.C.

PICTORIAL STATIONARY CO., 23, Moorfields, E.C.

ROCK BROS., LIMITED, 69, Paul Street, Finsbury, E.C.

RIEHMER, OTTO, 22, Wilmington Square.

SHARP, W. N., Gt. Northern Printing Works, Bradford.

STORRER, THOS., AND SON, 48, Canal Street, Nottingham.

STRAIN, W., AND SONS, 60, Great Victoria Street, Belfast.

SCOTT, A., AND CO., 45, Finsbury Pavement (hand-painted Xmas Cards).

SMITH, VAL ROSA, AND CO., 67, Wilson Street, Finsbury.

SUMMERFIELD, H. M., 1, Fann Street, E.C.

SPOTTISWOODE AND CO., Great New Street, Fetter Lane, E.C.

SHEFFER, J. W., 37, Walbrook, E.C.

SENLINNE AND GREEN, 66, Berners Street, W.

STENGEL AND CO., 39, Redcross Street, E.C.

STEWART, G., AND CO., 31, Paternoster Square, E.C.

STEWART AND WOOLF, 8, Charles Street, Hatton Garden, E.C.

TAYLOR, D. F., AND CO., Newhall Works, George Street Parade, Birmingham.

TILLOTSON AND SON, Mealhouse Lane, Bolton, and 188, Fleet Street, E.C.

TAYLOR BROS., Steam Colour Printing Works, Leeds.

THOMAS, J., AND CO., Neville Street, School Close, Leeds.

THOMAS, ANGUS, 4, Silk Street, E.C.

TUCK, RAPHAEL, AND CO., LIMITED, Raphael House, Moorfields, City.

TUCKER, A. J., 43, Barbican, E.C.

TIDBALL, SAW AND KING, 19, Paternoster Row, E.C.

TODD, S. A. C., 26, Bothwell Street, Glasgow.

UPTON, JAMES, Cambridge Street, Birmingham.

VOIGHT AND CO., 11, Crooked Lane, Cannon Street, E.C.

VOISEY, CHAS., 8a, City Road, E.C.

WIDDOWSON AND CO., 16, Millstone Lane, Leicester.

WILKINS, E.C., 17, Bartholomew Row, Birmingham.

WIDD, A., Castle Works, Grattan Road, Bradford.

WHEELER, W. G., AND CO., 51, Paternoster Row.

WALLER AND CO., 6, St. Benet Place, E.C.

WATSON, JAMES, AND SONS, 31, Tib Street, Manchester.

WALSH, JOHN, Portland Street, Halifax.

WOODLAND AND MOORE, 20, High Street, Runcorn.

WOOLRANCH, R., 52, Mansell Street, Aldgate.

WRENCH, 2, Arthur Street, Oxford Street, W. (Postcards only).

WOOD, J. T., 8, Plumtree Court, Farringdon Street.

WOOLSTONE BROS., 14, Chapel Street, Milton Street, E.C.

WINDERLICH AND CO., 5, Farringdon Avenue, E.C.

LITERARY AGENTS

AUTHORS' SYNDICATE, 5-7, Southampton Street, Strand, W.C. T.A.,
Another, London; T., 4344 Central.

BROWN, CURTIS, 5, Henrietta Street, W.C. T.A., Axinite, London; T.,
1,350 Central.

BURGHES, A. M., 34, Paternoster Row, E.C.

FINCH, JAMES, 1, Arundel Street, Strand, W.C.

LITERARY AGENCY OF LONDON, 5, Henrietta Street, W.C. T.A.,
Georyque, London; T., 4060 Gerrard.

PINKER, J, B., 1, Arundel Street, Strand, W.C. T., 1809 Gerrard.

WATT, A. P., AND SON, Hastings House, Norfolk Street, Strand, W.C.
T.A., Longevity, London; T., 5355, Gerrard.

NOTES ON XMAS CARD, POST CARD, AND SHOW CARD WORK.

Xmas card designs should be ready at least eighteen months before the
season for which they are intended, i.e., cards for Xmas, 1908, should be
submitted for approval in the early months of 1907. Pictorial post cards
should be in a series of six; of which one, at least, should be carefully
finished, the others may be in rough sketches, to show the idea of series.

In both cases flat colouring will be found to be more in demand than
any other process, and as few colours as possible should be used to save
expensive reproduction. Pastel is the most expensive process to reproduce.
Except when reproduction by photography is intended, designs should be
actual size of card when finished.

Magazine and catalogue covers should be brightly coloured, and when
figures are introduced it is essential that the faces be pretty.

Poster designs should be submitted when in the rough; a sketch the size
of a sheet of foolscap, with colour scheme suggested, is quite sufficient. It
should be borne in mind that the lettering is of great importance in posters
and show cards, and a prominent position should be given to it. It should
also be remembered that a poster or show card is an advertisement first, and
a picture afterwards. The idea must be novel and striking, easily under-
stood and recognisable from long distances. There must be nothing morbid
in it.

CLASSIFIED INDEX

SHORT STORIES.

All Story Magazine
Ally Sloper
Answers
Badminton Magazine
Big Budget
Black and White
Blackwood's Magazine
Boys' and Girls' Magazine
Boys' Friend
Boys' Herald
Boys of the Empire
Boys' Own Paper
Boys' Realm
British Workman
Bystander
Car
Captain
Cassell's Magazine
Cassell's Saturday Journal
C. B. Fry's Magazine
Chamber's Journal
Chatterbox
Children's Friend
Child's Own Magazine
Christian Commonwealth
Chums
Comic Life
Cornhill Magazine
Court Circular
Dawn of Day
English Illustrated Magazine
Evening News
Family Friend
Family Herald
Family Pocket Stories
Forget-me-not
Free Churchman
Gentleman's Magazine
Gentlewoman
Girls' Friend
Girls' Own Paper
Girls' Realm
Golden Sunbeams
Good Words

Grand Magazine
Graphic
Halfpenny Comic
Happy Hour Series
Hearth and Home
Home Chat
Home Circle
Home Life Magazine
Home Words
Horner's Weekly
Idler
Illustrated Bits
Illustrated London News
Illustrated Sporting and Dramatic
Jabberwock
Jester
Judy
Juvenile Templar
King and His Army and Navy
Ladies' Field
Lady
Lady of Fashion
Lady's Companion
Lady's Pictorial
Lady's Realm
Lady's World
Leisure Hour
Life and Work
Little Folks
Lloyd's Weekly Newspaper
London Magazine
London Opinion and To-day
M.A.P.
Macmillan's Magazine
Madame
Methodist Recorder
Methodist Times
Nuggets
Onlooker
Our Darlings
Our Home
Our Little Dots
Our Own Magazine
Outlook

Pall Mall Magazine
Pearson's Magazine
Pearson's Weekly
Penny Magazine
People's Friend
Pictorial Comedy
Pictorial Magazine
Playtime
Quiver
Red Letter
Rosebud
Royal Magazine
St. Nicholas
Scraps
Scribner's Magazine
Select Stories
Smart Set
Something to Read
Star
Strand Magazine
Sunday
Sunday at Home
Sunday Circle
Sunday Chronicle
Sunday Companion
Sunday Magazine

Sunday School Chronicle
Sunday Strand
T.A.T.
Temple Bar
Thrilling Life Stories
Tit-Bits
Town Topics
Treasury
Truth
Weekly Budget
Weekly Scotsman
Weekly Telegraph
Weekly Times and Echo
Westminster Gazette
Windsor Magazine
Woman
Woman at Home
Woman's Life
Woman's World
World
World and His Wife
Young Days
Young England
Young Man
Young People
Young Woman

SERIAL OR LONG STORIES.

Boys' Friend
Boys' Herald
Boys' Own Paper
Boys' Realm
Captain
Chambers's Journal
Christian Age
Christian Commonwealth
Christian Herald
Chums
Church Family Newspaper
Comic Life
Dainty Novels
Empire Bouquet Novels
Family Herald
Family Herald Supplement
Family Story-Teller
Fireside Novelist
Gainsborough Novels
Girls' Friend
Girls' Own Paper
Girls' Realm
Golden Stories
Good Words
Graphic
Halfpenny Comic
Halfpenny Surprise

Harper's Magazine
Home Companion
Home Messenger
Home Stories
Horner's Penny Stories
Horner's Pocket Library
Horner's Weekly
Illustrated Family Novelist
Illustrated London News
Illustrated Mail
Independent Review
Lady
Lady's Own Novelette
Lady's World
Life and Work
Little Folks
Lloyd's Weekly News
Macmillan's Magazine
McClure's Magazine
Marvel Library
Mayflower Novelette
Miniature Novels
Mirror Novels
Monthly Magazine of Fiction
Munsey's Magazine
My Pocket Novels
My Queen Library

Novel Magazine
Novelist
Nuggets
Our Home
Pearson's Magazine
Pictorial Magazine
Pluck
Princess Novel
Quiver
Red Letter
Royal Magazine
Scraps
Scribner's Magazine
Select Stories
Sixpenny Magazine of Fiction
Smart Novels

Smart Set
Something to Read
Strand Magazine
Sunday at Home
Sunday School Chronicde
Sunday Magazine
Sunday Strand
Sunday Stories
Tit-Bits
Union Jack Library
Weekly Budget
Weekly Telegraph
Windsor Magazine
Woman
Woman's World
Yes or No.

GENERAL ARTICLES.

Answers
Badminton Magazine (Sport)
Baily's Magazine of Sports and
 Pastimes
Bible Christian Magazine
Black and White
Blackwood's Magazine
Boys' Own Paper
British Empire Review
British Workman
Bye-Gones
Bystander
Captain
Cassell's Magazine
Cassell's Saturday Journal
Century Magazine
Chambers's Journal
Children's Friend
Child's Companion
Child's Own Magazine
Christian Age
Christian Commonwealth
Christian Globe
Christian Herald
Christian World
Chums
Church Bells and Illustrated
 Church News
Church Family Newspaper
Churchman
Commonwealth
Contemporary Review
Cornhill Magazine
Cottager and Artisan
Country Life
Country-Side

County Gentleman and Land and
 Water
Court Journal
Daily Chronicle
Daily Express
Daily Graphic
Daily Mail
Daily News
Daily Telegraph
Empire Bouquet Novels
English Illustrated Magazine
English Historical Review
English Review
Englishwoman's Review
Evening News
Evening Standard and St James's
 Gazette
Family Friend
Family Herald
Farm and Home
Farm, Field, and Fireside
Feathered World
Field
Fireside
Fishing Gazette
Fore's Sporting Notes and Sketches
Forget-me-not
Fortnightly Review
Free Churchman
Gentleman's Magazine
Gentlewoman
Girls' Own Paper
Girls' Realm
Gleam
Globe
Good Words

Grand Magazine
Graphic
Guardian
Harper's Magazine
Hearth and Home
Helping Words
Hibbert Journal
Home Chat
Home Circle
Home Counties Magazine
Home Life Magazine
Home Messenger
Home Notes
Home Words
Illustrated London News
Illustrated Mail
Illustrated Sporting and Dramatic
 News
Independent Review
Jabberwock
Juvenile Templar
King and His Army and Navy
Ladies' Field
Lady
Lady's Companion
Lady of Fashion
Lady's Pictorial
Lady's Realm
Lady's World
Leslie's Weekly
Life and Work
Little Folks
Lippincott's Magazine
Lloyd's Weekly News
London Magazine
London Opinion and To-day
London Quarterly Review
Macmillan's Magazine
Madame
Methodist Recorder
Methodist Times
Military Mail
Month
Monthly Review
Morning Advertiser
Morning Leader
Morning Post
Mother's Treasury
Motorist and Traveller
Munsey's Magazine
Myra's Journal
National Review
Nature Notes
New Age
New Ireland Review
Nineteenth Century and After
Observer

Our Boys and Girls
Our Darlings
Our Home
Outlook
Pall Mall Gazette
Pall Mall Magazine
Pearson's Magazine
Pearson's Weekly
Pelican
Penny Illustrated Paper
Penny Magazine
People
People's Friend
Pick-me-up
Pictorial Magazine
Playtime
Political Science Quarterly
Primitive Methodist Quarterly
Punch
Quarterly Review
Queen
Quiver
Record
Red Letter
Referee
Regiment
Review of Theology and Philosophy
Reynolds's Newspaper
Rosebud
Royal Magazine
St. James's Budget
St. Nicholas' Magazine
Saturday Review
Scottish Field
Scraps
Scribner's Magazine
Short Stories
Sketch
Smart Set
South Africa
South American Journal
Speaker
Spectator
Sphere
Sporting Times
Stage
Standard
Strand Magazine
Sun
Sunday
Sunday Circle
Sunday Companion
Sunday Magazine
Sunday Strand
Sunday Times
T.A.T.
T.P.'s Weekly

Tatler
Temple Bar
Times
Tit-Bits
Treasury
Truth
United Temperance Gazette
University Review
Vanity Fair
War Cry
War Office Times
Weekly Budget
Weekly Dispatch
Weekly Scotsman
Weekly Telegraph
Weekly Times and Écho

Week's Survey
Westminster Gazette
Westminster Review
Wide World Magazine
Windsor Magazine
Woman
Woman at Home
Woman's Life
Womanhood
Workman's Messenger
World and His Wife
World of Dress
World's Work and Play
Young England
Young Man
Young Woman

PARAGRAPHS AND NEWS NOTES.

Art Journal
Autocar
British Monthly
British Weekly
Car
Cassell's Saturday Journal
Christian
Christian Globe
Christian Life
Christian World
Church Bells and Illustrated
 Church News
Church Times
County Gentleman and Land and
 Water.
Country Life
Court Circular
Court Journal
Cyclist's Touring Club Gazette
Daily Chronicle
Daily Dispatch
Daily Graphic
Daily Illustrated Mirror
Daily Mail
Daily News
Echo
Engineering Magazine
Evening News
Farm, Field, and Fireside
Guardian
Illustrated Sporting and Dramatic
 News
Lady
Lady's Pictorial
Lloyd's Weekly News
Modern Society

Morning Advertiser
Morning Leader
Morning Post
Motor News
Musical News
Nature Notes
News of the World
Onlooker
Outlook
Pall Mall Gazette
Pearson's Weekly
Pelican
Penny Illustrated Paper
People
Queen
Record
Reynolds's Weekly Newspaper
Referee
Sphere
Standard
Star
Sun
Sunday Chronicle
Sunday Times and Sunday Special
Sunday Sun
Tablet
Tatler
Town Topics
Truth
Vanity Fair
Weekly Dispatch
Weekly Scotsman
Weekly Telegraph
Weekly Times and Echo
Yachtsman
Yorkshire Weekly Post
Young Man

LITERARY ARTICLES.

Academy
Athenaeum
Author
Book Monthly
Bookman
Church Times
Churchman
Edinburgh Review
English Historical Review
Fortnightly Review
Great Thoughts
Home Counties Magazines
Leisure Hour
Literary World
Lloyd's Weekly News

Modern Society
Month
New Age
Observer
Publishers' Circular
Review of Reviews
Saturday Review
Scottish Review
Speaker
Spectator
Sunday Sun
Sunday Times
T.P.'s Weekly
Temple Bar Magazine
Young Man

TECHNICAL AND TRADE ARTICLES.

Architectural Review
Aeronautical Journal
Agricultural Gazette
Alpine Journal
Amateur Gardening
Amateur Photographer
Anglo-Japanese Gazette
Anglo-Russian
Animals' Friend
Antiquary
Architectural Review
Army and Navy Gazette
Art Journal
Autocar
Automotor Journal.
Brain
British Journal of Nursing
British Printer
Broad Arrow
Builders' Journal
Building World
Burlington Magazine (Art)
C.T.C. Gazette
Cambrian Natural Observer
Cassier's Magazine
Celtic Review
Chemist and Druggist
Children's Quarterly
Church and Synagogue
City Press
Colliery Guardian
Commercial Intelligence
Connoisseur
Draper
Economic Review

Educational Times
Electrician
Electricity
Engineering Times
Engineering Magazine
Farm and Garden
Farm and Home
Feathered World
Fishing Gazette
Folklore
Furniture Record
Garden
Gardener
Gardening Illustrated
Gardening World
Genealogical Magazine
General Practitioner
Golfing
Grocer
Guardian
Health Resort
International Journal of Ethics
International Musical Journal
Investors' Chronicle
Iron and Coal Trades Review
Ironmonger
Jewish Chronicle
Jewish World
Knowledge
Lancet
Law Magazine
Law Times
Live Stock
Magazine of Commerce
Magazine of Fine Arts

Man
Mercantile Guardian
Military Mail
Mining Journal
Modern Language Review
Motor Car Magazine
Motoring
Musical World
Naturalist
Nature
Nature Notes
Nautical Magazine
Northern Notes and Queries
Notes and Queries
Optician
Pharmaceutical Journal
Philanthropist
Photographic Chat
Photographic Monthly
Photographic News
Photography
Pigeons and Poultry
Poultry

Political Science Quarterly
Pricher's Magazine
Progress
Public Health
Public Works
Railway Magazine
Review (Assurance)
Royal Asiatic Journal
School
School World
Schoolmaster
Schoolmistress
Science Siftings
Scottish Historical Review
Scottish Mountaineering Club Journal
South Africa
Studio
Theosophical Review
United Service Magazine
Work
Yachtsman
Zoophilist

ILLUSTRATIONS.

Agricultural Gazette
Ally Sloper
Alpine Journal
Amateur Photographer
Animals' Friend
Antiquary
Architectural Review
Art Journal
Autocar
Automotor Journal
Badminton Magazine
Baily's Magazine of Sports and
 Pastimes
Black and White
Book Monthly
Bookman
Boudoir
Boys' and Girls' Magazine
Boys' Friend
Boys' Herald
Boys of the Empire
Boys' Realm
British Empire Review
British Workman
Burlington Magazine
Bystander
Car
Captain
Cassell's Magazine
C. B. Fry's Magazine

Children's Friend
Chums
Connoisseur
Country Life
Country-side
County Gentleman and Land and
 Water
Daily Express
Daily Graphic
Daily Mail
Daily Mirror
Engineering Magazine
English Illustrated Magazine
Farm and Garden
Farm, Field, and Fireside
Field
Gardener
Gardening World
Gentlewoman
Girls' Own Paper
Graphic
Hearth and Home
Helping Words
Home Chat
Home Life Magazine
Home Notes
Idler
Illustrated London News
Illustrated Mail
Illustrated Sporting and Dramatic

Illustrated Temperance Monthly
Jabberwock
Judy
King and His Army and Navy
Knowledge
Ladies' Field
Lady
Lady of Fashion
Lady's Pictorial
Lady's Realm
Life and Work
Literary World
Little Folks
London Magazine
London Opinion and To-day
Madame
Methodist Recorder
Military Mail
Morning Leader
Motoring Illustrated
Onlooker
Our Darlings
Our Little Dots
Pall Mall Magazine
Pearson's Magazine
Penny Illustrated Paper
Penny Magazine
People's Friend
Photo Bits
Photographic News
Pick-me-up
Pictorial Comedy
Pictorial Magazine
Pluck
Punch
Queen
Quiver

Regiment
Reliquary
Review of Reviews
Rosebud
Royal Magazine
St. Nicholas
Science Siftings
Scottish Field
Scraps
Sketch
Sphere
Strand Magazine
Studio
Sunday
Sunday at Home
Sunday Circle
Sunday Companion
Sunday Magazine
Sunday Strand
Tatler
Treasury
War Cry
Weekly Budget
Weekly Dispatch
Westminster Gazette
Wide World Magazine
Windsor Magazine
Woman at Home
Woman's Life
Work
World and His Wife
World's Work and Play
Young Days
Young Man
Young People
Young Woman

JOKES.

Ally Sloper
Answers
Big Budget
Comic Life
Judy

Nuggets
Pick-me-up
Punch
Scraps

GUIDE TO AUTHORS.

It is to be observed, that the *figures* on the margin are not used in
correcting, except where, by the corrections being very numerous,
the printer might be led to mistake one alteration for another. The
figures are here only used for the sake of explanation.

THOUGH a variety of opinions exists as to the indi- 1 *a*

vidual by whom the art of printing was first discovered ; 2 9

yet all authorities concur in admitting Peter Schoeffer 3 *L Caps.*

to be the person who invented *cast metal types*, having

learned the art of of *cutting* the letters from the Gut- 4 δ

temmbergs / he is also supposed to have been the first 5 δ/ 6 :/

whoengraved on copper ∧ plates. The following testi- 7 ⚏ 8 /-/

mony is preseved in the family of Jno. Fred. Faustus 9 ∧ *r*

of Ascheffenburg : [" Peter Schoeffer of Gernsheim, per- 10 [*N.P.* 11 *S C*

ceiving his master Fausts design, and being himself 12 '/

desirous[ardently to improve the art, found out (by the 13 *tr.*

good providence of God) the method of cutting (*incidendi*) 14 | 15 *Stet.*

the characters in a *matrix*, that the letters might be easily

singly *cast*, instead of bieng *cut*. He privately *cut matrices* 16 *ei.*

for the whole alphabet : ∧Faust was so pleased with the 17 *See below.*

18 contrivance, that he promised Peter his only daughter 19 *w.f.*

Christina in marriage, a promise which he soon after

performed. 20 *Run on.*

But there were many difficulties at first with these 21 *as.*

letters, as there had been before with wooden ones, the 22 *Rom.* 23 *Ital,*

metal being too soft to sup port the force of the impres- 24 ⌣

sion ; but this defect was soon remedied, by mixing

a substance with the metal which sufficiently hardenedit /" 25 *tr.* 26 ⊙

∧ and when he shewed his master the letters cast from these matrices,

THOUGH a variety of opinions exists as to the individual by whom the art of printing was first discovered; yet all authorities concur in admitting PETER SCHOEFFER to be the person who invented *cast metal types*, having learned the art of *cutting* the letters from the Guttembergs: he is also supposed to have been the first who engraved on copperplates. The following testimony is preserved in the family of Jno. Fred. Faustus of Ascheffenburg:

"PETER SCHOEFFER of Gernsheim perceiving his master Faust's design, and being himself ardently desirous to improve the art, found out (by the good providence of God) the method of cutting (*incidendi*) the characters in a *matrix*, that the letters might be easily singly *cast*, instead of being *cut*. He privately *cut matrices* for the whole alphabet: and when he shewed his master the letters cast from these matrices, Faust was so pleased with the contrivance, that he promised Peter his only daughter Christina in marriage, a promise which he soon after performed. But there were as many difficulties at first with these letters, as there had been before with *wooden ones*, the metal being too soft to support the force of the impression; but this defect was soon remedied by mixing the metal with a substance which sufficiently hardened it."

EXPLANATION OF CORRECTIONS.

A *wrong letter* in a word is noticed by drawing a perpendicular line through it, and marking the proper letter on the margin, opposite the faulty letter. See No. 1.

A *turned letter* is noticed by making a dash under it, and by the mark No. 2 on the margin.

If letters or words are to be *altered from one character to another*, a parallel line or lines should be marked underneath the word or letter, viz. for large CAPITALS, three lines; small CAPITALS, two lines; and *italics*, one line; and on the margin opposite should be written L. Caps., S. Caps., or Ital. See Nos. 3, 11, 22, 23.

When letters or words are *set double*, or are required to be taken out, a line is drawn through the superfluous letter or word, and the mark Nos. 4 and 5 placed on the margin.

Where the *punctuation requires to be altered*, the semicolon, colon, &c., should be marked on the margin with a score behind them, as shown by No. 6; but the period should be encircled, as represented by No. 26.

When *space is wanting* between two words or letters, which are to be separated, a caret should be made where the separation ought to be, and the sign No. 7 placed opposite on the margin.

No. 8 shews the manner in which the *hyphen* is marked.

Should a *letter* or *word have been omitted*, a caret is put at the place, and the letter or word is marked on the margin, as Nos. 9 and 21.

When a *new paragraph* is required, a parallel line or lines should be made, and the same mark placed on the margin, with the letters *N. P.* or *N. L.* See No. 10.

No. 12 shews the way in which the *apostrophe, inverted comma, star*, and other references and superior letters and figures are marked.

Where *two or more* words are *transposed*, they should be marked with a line above and below, and *tr.* marked opposite, as is done in No. 13, or as shewn in Nos. 16 and 25.

Where a *space* sticks up between two words, a perpendicular line is put on the margin. No. 14.

Where *words have been struck out that have afterwards been approved of*, dots should be marked under such words, and in the margin should be written *Stet*. No. 15.

Where several *lines* or *words* are *added*, they should be written at the top or bottom of the page, with a reference mark, a corresponding reference being made at the place where the insertion begins (See No. 17.), or if the addition be on a separate Sheet, then the words *See paper apart* should be written on the margin.

Where *letters* or *lines stand crooked*, they are noticed by drawing lines above and below them. No. 18.

When a *smaller* or *larger letter* than that on which the work is printed is improperly introduced into the page, it is noticed by a perpendicular line being drawn through it, and the mark *w.f.* (wrong fount) written on the margin. No. 19.

If a *paragraph* be improperly made, a line should be drawn from the one sentence to the other, and the words *run on* written on the margin, as in No. 20.

Where *words* or *letters* that should *join* are separated, the mark No. 24 must be placed under the separation, and the junction signified by the same on the margin.

In all cases, but particularly in those where the author has it not in his power to see the proof sheets, accuracy and distinctness of copy are particularly desirable. If attention be paid to the right spelling of the names of persons and places, technical terms, &c., the finishing of sentences marked by the period,—that the author's ideas may not be misunderstood,—and the handwriting tolerably legible, much time and a very considerable expense will be saved, and the great object of accuracy attained.

When a proof is returned, finally corrected for printing, the word PRESS should be

Lightning Source UK Ltd.
Milton Keynes UK
UKHW020027100223
416723UK00004B/137

9 781016 280167